ngc

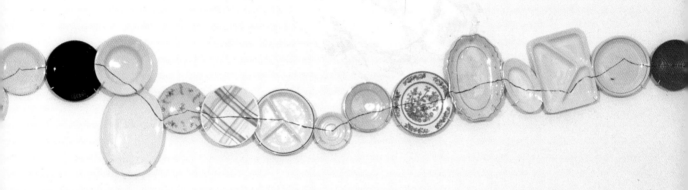

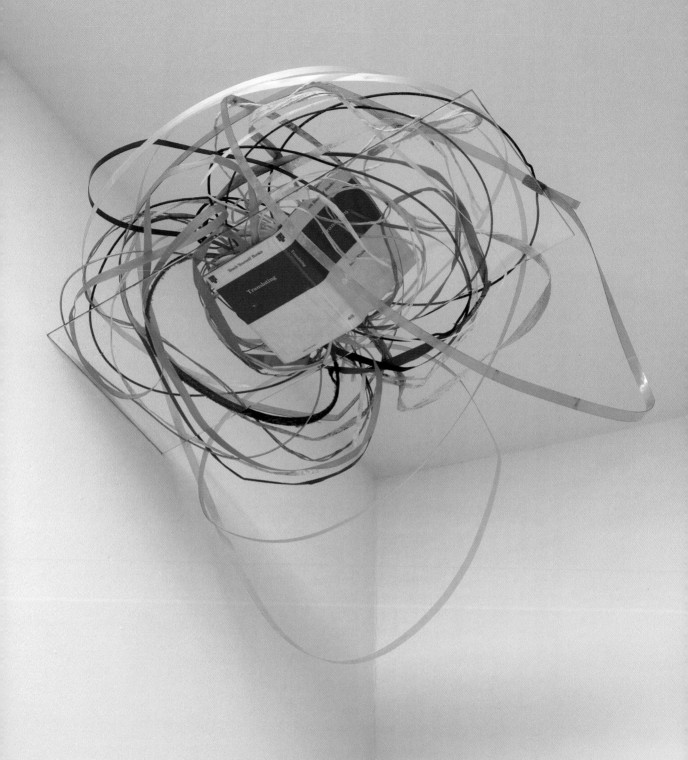

The Loops 1999
Book, assorted plastics and metals on glass

Richard Wentworth

LIVERPOOL
TATE

LISSON GALLERY

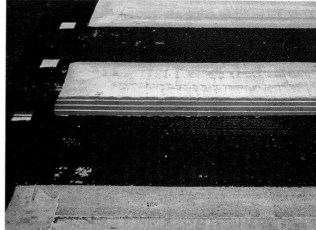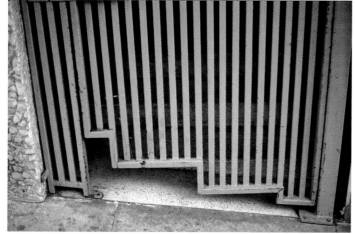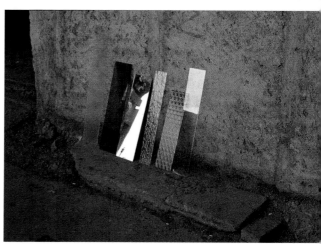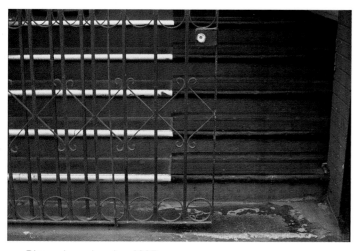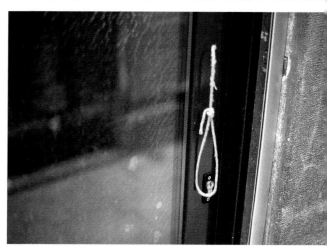

Bloomsbury, London 1997
San Francisco 2001
San Francisco 2001

Islington, London 1999
Tirana 1999
Venice 2001

From the series Making Do & Getting By and Occasional Geometries

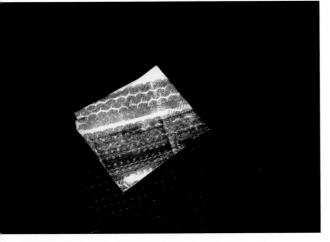

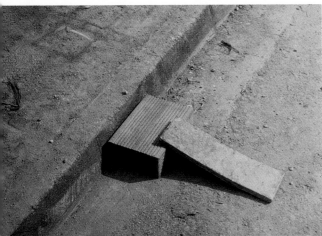

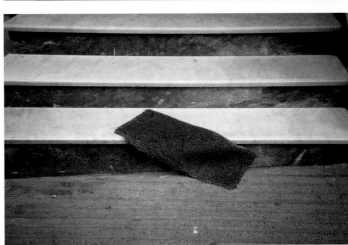

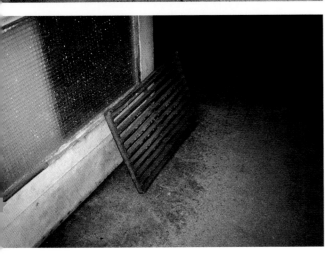

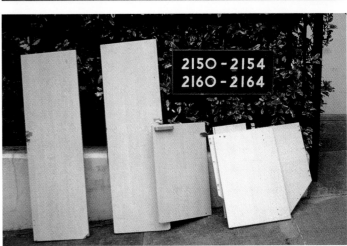

arcelona 1994

icosia 2001

erlin 1994

Islington, London 1989

Instanbul 1992

San Francisco 2001

'So Much Depends': An Introduction to the Art of Richard Wentworth

Michael Bracewell

The pristine frame of a metal bucket; a shelving unit, precariously tilted; a box suspended in an angry cyclone of packing tape; an old dictionary stuffed with electrical entrails – or another, crammed with gaudy sweet wrappers.

And photographs (all colour): furniture, sunlit on a pavement; junked car parts wedged in a doorway; a tin of peas holding a shop door open; a cement mixer, a pile of earth and an arrangement of planks, like some abandoned circus act.

When you look at the art of Richard Wentworth, you see materials and objects which appear domestic, industrial or discarded, their function skewed or broken. Stuff from the depths of workshop cupboards or the backs of charity shops; the kind of light industrial leftovers and spare parts produced without pause by the relentless momentum of commodity culture.

But as these components are fused or arranged or assembled by Wentworth into new forms and shapes, or photographed by him (their oddity caught as occurrences within the landscape), so they begin to tease and massage our perception of them. Their banality becomes transfigured, their shape converted to some unknowable purpose, but their emptiness filled with meaning. You are looking at what appears to be some collaboration between sculpture at its most refined and the seductive environmental doodling described by found objects.

In its games with weight and strangeness, its humour – at once absurd, devoutly unironic and melancholy – and its ever-present microclimate of anxiety, the art of Richard Wentworth (coincidentally, like the poems of William Carlos Williams) identifies what we could call the secret history of the quotidian. Shed-shaped metal forms are suspended overhead (like an earth-to-heaven view of Dorothy's prairie home, en route by tornado to Oz), or perched in a cradle of folded steel rope; crockery holds tight on a sloping shelf. Anonymous presences make themselves felt. As, for William Carlos Williams, 'so much depends' on 'the red wheel barrow' which his poem describes, 'glazed with rain water', so for Wentworth you feel that everything and nothing are fused within the poise and high refinement of his abutted objects and precarious *mises-en-scène*.

The once mute, mutated tool (an inverted ladder, for example, its sides narrowed at one end to a single rubberised stump) appears intimate and troubling; the fresh machine-cut parts – aluminium casing, glass shelves – acquire, shall we say, a veiled intentionality. Reconfigured as art, these components own a gravitational field which draws you into their world, whatever that stilled yet heady place, in which appearances, values and sensations are the same but rearranged, might be said to comprise. One

answer might be that the art of Richard Wentworth makes diagrammatic connections of profound aesthetic acuity between our personal and historical experience of the modern world. Describing a late phase of the Mass Age (the latter decades of the last century onwards), in which there is an abundance of mass-produced objects – the landscape of the urban conurbation, the industrial hinterland and the retail park – his art seems to pose manifold riddles: hybrid psychological one-liners, as though tutored in the flamboyant rhetoric of surrealism but told in a brutalist language of contemporary manufacturing processes.

Simultaneously, Richard Wentworth has created an artistic language which articulates a rearrangement of the periodic table of cultural status, exploring the ways in which the landscape, technologies and clutter of the modern world, the maintenance and manufacture of its fabric, the litter and discard of its processes, the accidental and the chanced upon, can provide the materials and media for excursions into the human consciousness. In this his art identifies the point at which the monolithic processes of mass production and mass media collide with a sense of individual human enquiry, in all its ingenuity, frailty, anxious searching and irrationality.

Thus Richard Wentworth makes art which presents the viewer with objects that are also situations; in their turn, these situations can appear simultaneously meaningless and profound, declamatory and enigmatic. They seem to be held together by the sheer accumulated force of their internal contradictions and opposing tensions. To quote from the maxims of the Danish philosopher (and high priest of the intractable) Søren Kierkegaard, they are 'like the chess piece of which you say, "that piece cannot be moved"'. But then there is a further aspect, hooking up the circuitry of their extraordinary animation, and the force-field of their timeless modernity. We could look to pop for some help with this. Back in 1966, pouting and pronouncing the sheen and certainty of the modern world to mask volatility, shape-shifting and dead drops into sudden anxiety, the Who sang on their single 'Substitute' that 'the simple things you see are all complicated…'. It was a determinedly, elegantly, dizzying lyric. Within its imagery, nothing was as it seemed, everything celebrated for its conversion into something else. Stroppy, confrontational, deftly at ease with surfing the materials of modern life, 'Substitute' invoked a sort of pleasure and bravura insolence in the tangles and curves of instant transformations – of values and status turned on their heads, and of creating vertigo for those seeking a fixed point.

When you combine these two seemingly opposed perspectives – Kierkegaard's immovable chess piece and the Who's complicated simplicity – they create a third effect, hard as nails, forged from their contradiction of each other: namely, to evoke that which is locked in a process of change. And so the art of Richard Wentworth, in this regard, can be seen as reconfiguring the banal fabric and detritus of the modern world, but in a way which – with utmost, aphoristic certainty of purpose – renders its reconstituted, rearranged presence electrifyingly energised and mesmeric. His art thus

appears both taut and fluid, disturbed yet filled with stillness, simultaneously discarded and iconic, vivacious and sepulchral, poetic and industrial, tactile and resistant to touch.

These qualities develop as though from a merger between that which cannot be transformed and that which is in a permanent state of transformation: a shelving unit caught in the act of falling, for example, which might also not be a shelving unit at all, but a device, constructed in its correct position, for allowing objects to fall. Likewise a modern-style office desk, its top sectioned into coloured angular segments, but crudely studded with nails: boredom and violence, work and play, authority and attack, tool and ornament, *objet d'art* or evidence of psychosis? 'To will is to stir up paradoxes', writes Camus. The rewards of engaging with Richard Wentworth's art are immediate and visceral. There is a quality to his work which seems to speak directly to our experience of sensation. The tension in Wentworth's art most often seems to be that between passive and aggressive – fragility and density. In this, the situations created by these art objects are conveyed to our sensory imagination in advance, vitally, of the intellect's desire to 'solve' them. Unlike the delicate rococo tracery of postmodern mischief-making, however, the art of Richard Wentworth eschews irony, self-conscious quotation and the sheer aesthetic gorgeousness of fin-de-siècle decadence. Rather, in his fusion of the industrial, the anxious, the comic and the humble, he is an artist who confronts the substance and processes of post-industrialism with a purpose which might be compared to the excursions into the field of signs conducted by Roland Barthes.

For Wentworth shares with Barthes an insight into our relationship with the seductive illogicality of the modern landscape. At root, perhaps, he also shares Barthes's covert romanticism – the pleasure of the *flâneur*; the aesthetic connoisseurship of the philosopher-scientist. 'So much depends' – an aphorism to confound interpretation? But of course! Let mystery serve.

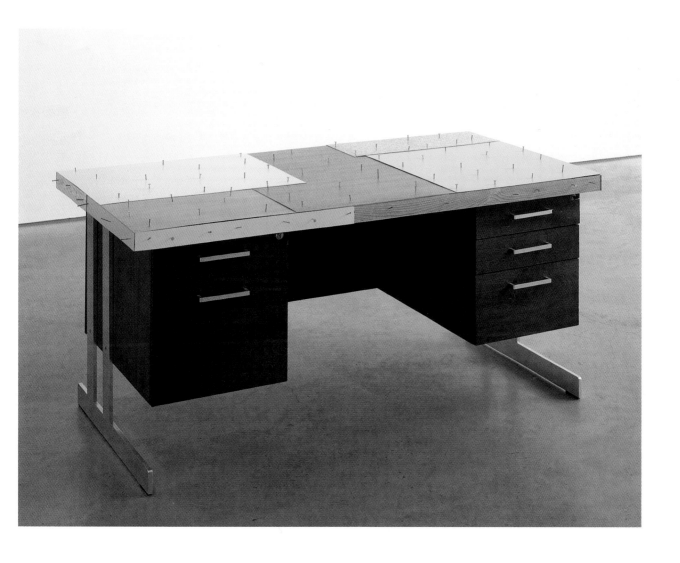

Roland Barthes' Desk 1997
Wood, aluminium, laminate and nails

Mirror, Mirror 2003
Galvanised steel, laminated glass and assorted dictionaries

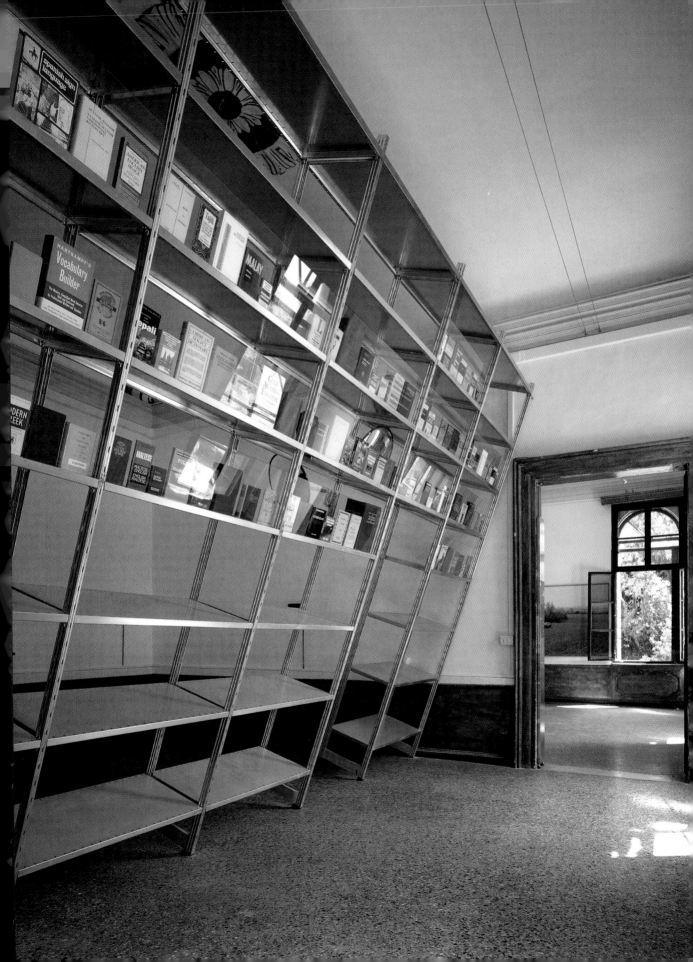

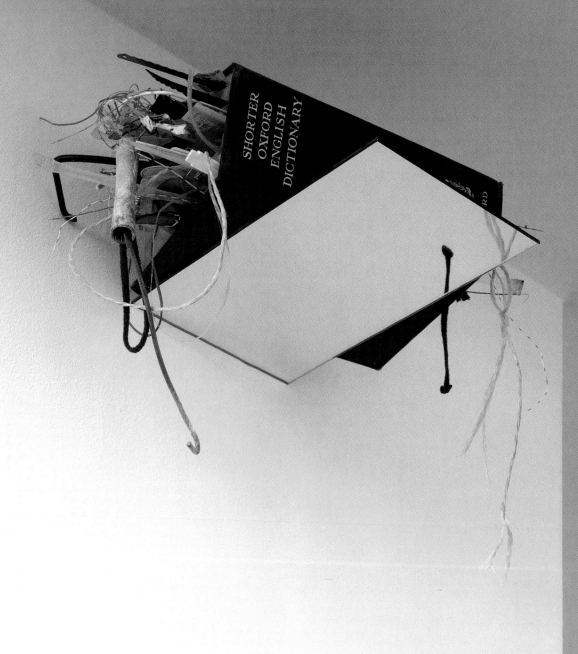

Twenty Seven Minutes, Twenty Two Nouns, Seven Adjectives 1999
Book and assorted materials on mirrored glass

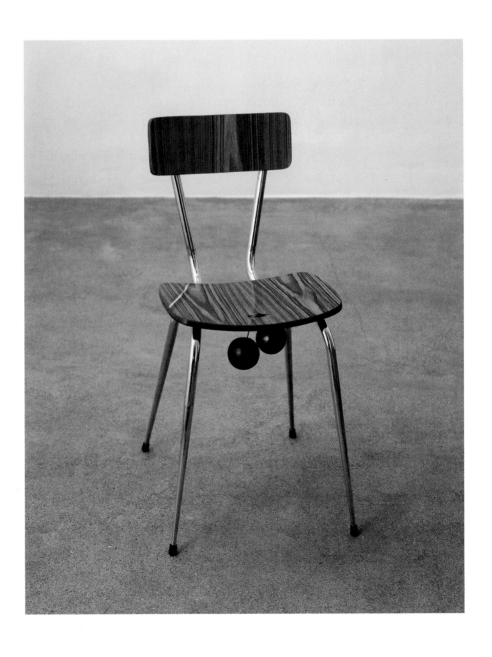

Lightweight Chair with Heavy Weights 1984
Steel, laminate, brass, cable and lead

Idiot Circle 1981
Wood and steel

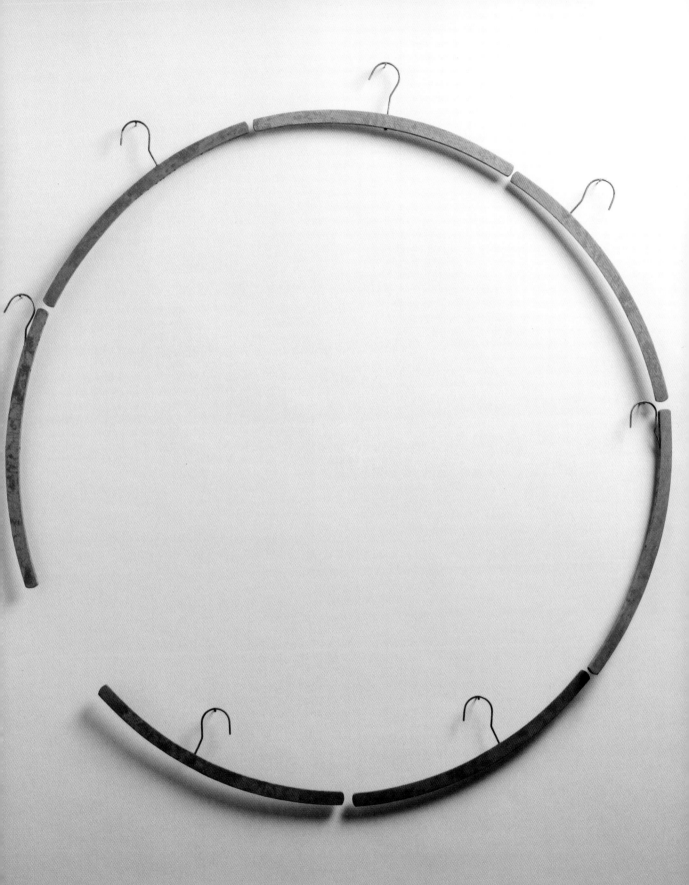

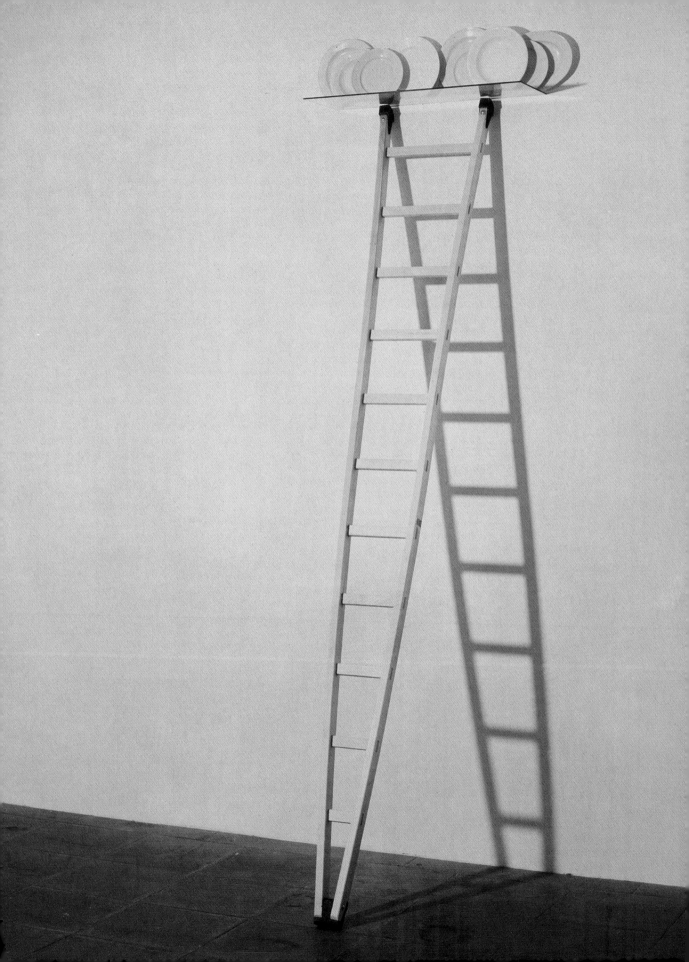

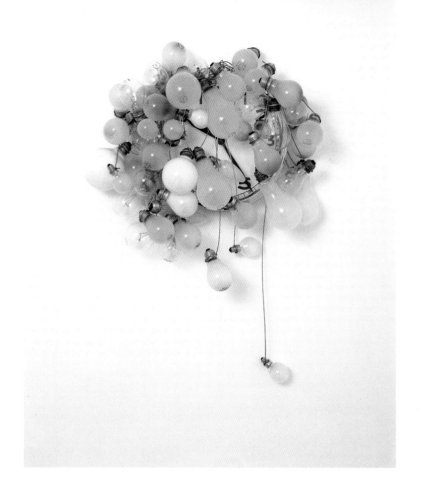

Cumulus 1991
Wood, rubber, glass and ceramic

Wick 1994
Clock with cable and dud lightbulbs

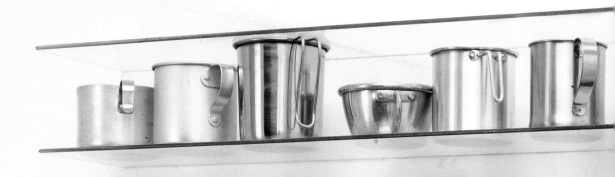

List (15 Months) 1994
Aluminium, stainless steel and glass

The Ungothroughsomeness of Stuff[1]

Roger Malbert

For an artist whose work is so succinct, Richard Wentworth is remarkably loquacious: 'Sometimes it frightens me how much I like to talk,' he says with a wry smile. 'Perhaps sculpture isn't really an adequate medium for me; should I have been a story-teller in a Moroccan market?' Words are another material, ready-made: 'I adore etymologies, the fact that words have all had a life and a history, they're all second-hand, but when we speak we conjoin them in totally new ways'. Richard's language is vivacious, his metaphors spontaneous, surprising. Often in his sculpture, mundane objects – 'iconic and generic at the same time' – are startled into some unexpected relationship; they are transformed into characters, gravitating towards or repelled by their neighbours. 'I'm interested in the fact that we ourselves are spatial, and how we place something in space is always conditioned by that. I like the fact that in French the word for "to place" is poser, which brings in the sense of stagy self-consciousness, of posing.' Richard Wentworth's way of looking at the world is, to all those who know him, unique and contagious. After time spent with his work or with him, the common experience is for the world to turn into 'a Wentworth', and this transformation is somewhat magical – momentary yet undeniable. Objects speak of human intention in ways that we usually ignore.

In the early 1970s, when the artist Jon Thompson was inventing Goldsmiths College according to his philosophy of art education,[2] Wentworth was one of the people he invited to teach: 'I always think of Richard as an intimate maker of things, as an object poet. He's entirely different from the rest of his generation, because he always wants the object to carry so much meaning, it has to do the work of language. This goes way beyond the visual and the formal into the realm of *poesis*. There's a social dimension to his work, it's about how you engage with matter and help to transform it. He has always been very good with his hands, and admires craftsmanship, but he doesn't believe in work for work's sake. He thinks that work has to be purposeful, which means that he makes something only when it seems right for him to do so. When he does, it is always incredibly well-constructed, but more than that, there's a connoisseurship in his judgement about the precise moment when an object comes into being. This is reflected in his photography, which shows his fascination with the ingeniousness of human endeavour. The small improvised solutions to practical problems that fascinate him are deeply human.'

To describe Richard Wentworth as an anthropologist or poet is to circle around the question of what makes an artist a particularly acute observer of human reality. It is in this generalised form that he himself would probably pose that question, regarding

himself as a member of an international community of artists with at least a few shared characteristics. 'Across the world people go to art schools. There's usually a group that feels closely connected to the stuff of the world, they know that if you catch your hand on the corner of this chair you'll be grazed, if you break this glass it will cut you.' Some artists tend to be sharply attuned to the codes and currents of the wider visual culture, and this awareness in Wentworth's case is informed by an extensive understanding of architecture, urbanism, material culture and social history. The American artist Tom Sachs says that it was the breadth of Wentworth's view – as a sculptor who understands how things are manufactured and how they fall apart – that was the biggest influence on him. As in the natural world, there are rules applying to everything that's made, determining its longevity – for example gloss paint lasts longer than matt paint, it reflects the light and weathers better. Sachs noted: 'I don't really think that the title *Making Do and Getting By* does [Wentworth's work] justice because it's about so many different things. It's really about the world. It has nothing to do with art but it has everything to do with it. When he was lecturing to students in San Francisco, he would show pictures he'd taken there, where so many themes were overlapping. I wouldn't want to break it down, his connections are lysergic (I prefer that to "multivalent", which sounds very academic). There would be a photo of a sheet metal fabricator's, with the whole building constructed from sheet metal and then covered in signs saying "sheet metal"; or a single glove planted on a fence, with its story of loss, also its graphic presence as a hand signal, a "stop" sign.'

At the Ruskin,[3] which Wentworth currently directs, one of his first acts was to remove the desk from his office and the screens dividing the students' studios. The challenge was to reinvent the spaces that determine interpersonal relations – in other words, how people behave. 'I'm conscious of the way students witness each other and how much of what we really learn is not by becoming studious but by watching others do things. We learn how to boil an egg by watching our mothers. We might ask later whether it should be six minutes or four, but the essential knowledge is gained through example.' Modern Art Oxford's chief curator Suzanne Cotter has been spending time with Wentworth recently driving between Oxford and London. 'I was struck by how much he notices things, things that you'd take for granted, like signs on the sides of trucks or the way four roads meet, and talks about them not just in visual terms, but as part of the larger world of economics and social history. He's so intensely engaged with the world, so connected with it, he's not an impartial observer and definitely not a *flâneur*. His observations have a way of opening up your understanding of things, the way they're used. I see him as humanist.'

That notion of humanism is paradoxical, because the human form never appears in Wentworth's work, except metaphorically or by association. His talk is, however, full of

people, and he seems to know everybody. 'I see him much more as a people person than a thing person,' says the designer Kit Grover. 'He sees people in things, he's interested in things with a previous owner, with a history of particular circumstances. And this is one way in which he can make objects exceed their boundaries. It's very emotional. He puts together completely unrelated objects as you might introduce people and they start to gravitate towards each other, to have a conversation. It's a weird act of alchemy. Small gestures take on the power of an epic statement. For example the dictionary stuffed with pieces of paper collected in the gutter like so many bookmarks; it's hard to pin down what's happening, but it is definitely not trivial, it has a real depth.'

Critics have sometimes characterised Wentworth's abbreviated style as 'witty', which is diminishing, especially when applied to 'English' art. However, the dialectic between humour and pathos is certainly a key to the deeper meaning of his work. It is significant for example that he cites the French comic actor Jacques Tati as a formative influence. Wentworth's lexicon of ladders and buckets and precarious tilts and tipping of tables and chairs is, of course, close to the primary elements of comedy. But there's an implication of danger in the precarious balance of things, the loss of equilibrium, the threat of the fall. After all, it may be funny for the onlooker, but a fall can result in real pain. 'Failure's an important part of the process of making art,' Wentworth observes. 'We proceed by trial and error, with lots of error. Artists understand the culture of the false start.' He recalls Bruce Nauman's video *Setting a Good Corner (Allegory and Metaphor)*. It's a performance piece, a kind of manual, showing the artist putting up a fence. 'He's actually saying that if you can't get a corner right you can't make a field; there are procedures in the world that inform the way we make things.' There is method-ological precision and care in Wentworth's seemingly nonchalant joining of everyday objects. The way two things are joined, the exactitude with which they are welded or embedded, is crucial to the formal success of a work. And certain formal predilections emerge: a love of circles, 'how they almost never are, you tilt a plate and it becomes an ellipse. But then, extruded circles are pipes, and bigger ones we call tubes; I'm interested in the mutability of things, the shifting vocabulary of materials, and the way we respond to change in the world around us with the implicit – but false – assumption that we ourselves remain unchanged.'

Many of those who know him speak of Richard as an 'artist's artist', and *Making Do and Getting By* (which Wentworth describes as the 'unendable record of my encounters with the provisional') is now acquiring a cult status. Nicholas Logsdail, his dealer for thirty years, perceives his influence in many younger artists, 'those who are canny in picking up the most significant examples from the previous generation'. He regards the obsessiveness with which Wentworth exposes the 'quirky peculiarities of our culture'

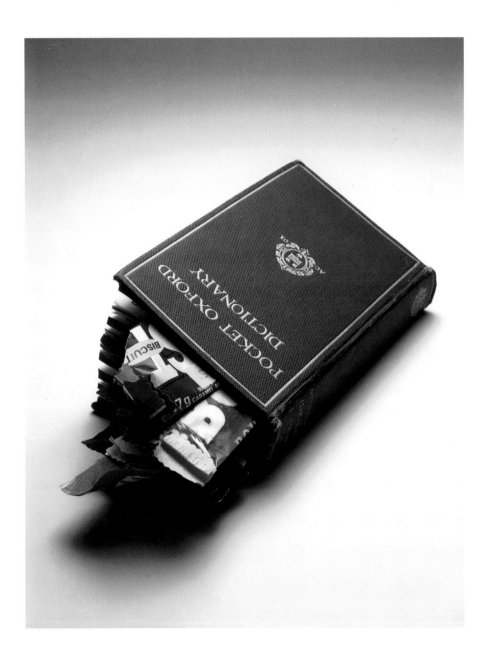

Tract (from Boost to Wham) 1993
Book with paper and plastics

as indicative of his character: uncompromising, eccentric, anti-establishment. Yet, for all its informality, there is a classical elegance to his work: 'It's interesting to look back, because when you scrutinise the earlier work, it doesn't look at all dated, as so much of the work of that time now does. It definitely stands the test of time. It looks authoritative, like classic art history.'

Marina Warner, who has written eloquently about Richard's work, says that 'over the thirty-five years that he's been making art he has become a kind of art form of his own. The atmosphere and method associated with him you see reflected now very widely. And the way he communicates personally – what he thinks about art and his way of seeing the world – is so original and vital.' She admires his lightness of touch: 'His way of working is very minimal, deft and nimble, with beautiful sleights of hand. He creates unexpected, tense, sometimes tender juxtapositions between mundane things, discovering the monumental in the provisional. He appears to be only interested in the made world. And I really do believe that he genuinely finds a drain cover more beautiful and interesting than a Rodin. His understanding of how human society expresses itself through tools is anthropological, and he's very alert to the coded meanings we assign to things, and how those codes come to seem natural. His turn of thinking is symbolic – the object or image as a sign – and he enjoys the way a change of function alters the meaning and status of things. He's able to create epiphanies of materials; he's very good on tactility, texture, the ebb and flow of material culture.'

Richard's preoccupation with the made world is confirmed by his wife Jane: 'When we go for a walk in the country, he's not that interested in the sky or the trees, he's always looking for the intervention of the human, the latch on a gate or the way a path has been formed by repeated treading. He's so good at making things and he's always felt a strong involvement with artisans; he can't pass someone plastering a wall or laying a hedge without stopping to talk about the tools they're using. He's interested in dirt, soil, pruning and husbandry, he's down to earth in that sense – he's a realist.' That realism is manifest in his appetite for travel (this he shares with Jane), particularly to 'difficult' places. The Albanian artist Lala Meredith Vula recalls time spent with him in Kosovo. 'He really enjoyed Pristina, where life is incredibly raw and on the edge and you see people mixing concrete in the middle of the road, or painting road markings freehand, or selling freshly split stone roofing stacked up by a roadside quarry. His lectures to students there were very inspiring and brought a lot of people together. It was good for them to see him show [in a selection of slides from *Making Do and Getting By*] that not everything runs smoothly over here, as they always assume.'

The artist Dorothy Cross spent two days in Ireland making a radio programme with Richard Wentworth, days consumed by continuous talk and hilarity: 'We've got the

West Hampstead, London 1979
Islington, London 2000

Bell Street, London 1987
New York 1978

From the series Making Do & Getting By and Occasional Geometries

gregarious bug', she declared at the time. She likes to think of him as a tinker: 'In Ireland, tinkers used to be respected, they moved around the countryside, helping out in the great houses, mending things and shoeing horses. In the old days they were unusual, inventive people who told stories and could see into the future. Originally they were tin-smiths, which fits nicely with Richard's interest in tin cans and buckets. I love the way he identifies with the peripheral, the neglected, and the alternative use of a thing. When he was staying with me we went to the hardware store up the road and he immediately found a tool that nobody ever uses any more, a relic that no one could even identify. What I find so inspiring is that his life is so totally integrated, he never stops functioning as an artist, he never switches off, he's always curious and enthusiastic. And there's a lack of ego in his work, in terms of the mark he leaves on things, the way he stands back and lets the fortuitous connections between things happen. And this to me makes it all the more valuable, in the head and the heart. He's not trying to make a grand, central statement; there'll never be a Richard Wentworth "brand". It's interesting to see the way he circumnavigates the art world, he's one of the few that refuse to be assimilated.'

Knowing Richard's suspicion of institutions, I asked Jon Thompson whether he would think of him as a rebel. 'Yes, but ultimately he's got far too highly developed a sense of social responsibility to be really rebellious.' He has, however, as Jane Wentworth affirms, 'got a real thing about authority, he can be provocative with policemen and officials of all kinds, which is often really embarrassing'. In Marina Warner's view, his rebelliousness is disguised by urbanity and his generous nature – something that is especially evident in his practice as a teacher and his support for younger artists. 'He is self-effacing, and often in his work his presence is hardly felt, there's a kind of vanishing act, a conjuring trick. In working with Artangel in London's King's Cross in 2002, for example, he created a setting where everyone in the area – including car-wash teams and the staff of the British Library – could be drawn in. That project was typically elusive, difficult to encompass, impossible to reproduce. In his attitudes he's very close to groups like *Arte Povera*, movements which were against commerce, the monumental, the commodity.'

The three-month-long Artangel event, *An Area of Outstanding Unnatural Beauty*, took place in a former factory near to the station, where Wentworth created a complex, cumulative installation, including a periscope, which overlooked the surrounding area of intensive development and was reached by a readymade stairwell imported from a container yard in the Isle of Dogs; every conceivable kind of map of London, from flight paths, geologies, and the route of the Channel Tunnel to William Booth's late Victorian maps of the population's economic living conditions; a cheval mirror from a men's outfitters; second-hand TV sets playing the original version of *The Ladykillers* and Wentworth's video of men setting out road markings. Artangel's James Lingwood worked

closely with the artist on the project. 'It grew out of discussions we had had about *Making Do...*, and whether it would be possible to reconfigure that densely layered vision which I admired so much in the slide shows in an actual space. Richard is very interested in territories and the demarcation of urban spaces and this work was multi-faceted in space and in media. It was meandering, making detours that embraced contingencies, the coexistence of different communities within the same location. So you'd have one group of people, a bunch of students from Goldsmiths, for example, coming in to hear a lecture about the enlarged spatial memory of taxi drivers while another group from the local minicab office played table tennis. The idea of "relational aesthetics" is very fashionable now, but I think it really does apply to Richard's way of working – conversational, genuinely open to other people's lives and work. Its scope is inexhaustible; his studio is the streets of London.'

The elaborate nature of the Artangel event, with its commingling of disparate elements – objects, artefacts, graphic signs, ideas and people – seems clearly to suggest a way forward for this restless, complicated artist. And in the interaction it prompted with miscellaneous publics, it affirms Wentworth's intense sociability. Like Claes Oldenburg's *The Store*, a work of the early sixties that Wentworth often cites as seminal, it occupied an ambiguous, peripheral space detached from the conventions of the gallery or studio or school. 'I like the gaps and seams and borders and margins, slippage in language and the uses we make of things – how we commandeer a chair to change a lightbulb, the way we retrieve a tea-bag with the wrong end of a biro...'. One last question: the best thing in the last five years? 'Sitting next to Richard Gregory[4] and meeting him for the first time, utterly overawed. Interviews taking place. After two or three, RG turns to me and before the whole panel declares in a loud gregorian voice, "You've got the most marvellous instinct, I can feel it literally coming off you!" (Remember he's a scientist).'

Acknowledgements
Thanks to those quoted in this essay who generously shared their thoughts on Richard and allowed me to pocket the (modest) fee. They are in fact just a few of the many who could have been asked: a longer list would have included architects, scientists, critics and broadcasters, inventors and many more artists, all of whom could have contributed additional layers to the cake.

1
'The impenetrability of matter' rendered in Anglo-Saxon English.

2
Jon Thompson led the Fine Art course at Goldsmiths College from 1970, introducing radical teaching methods that altered the culture of art education in Britain.

3
The Ruskin School of Drawing and Fine Art at Oxford University.

4
Experimental psychologist, whose most popular book, *Eye and Brain*, is fundamental reading for all those interested in visual perception.

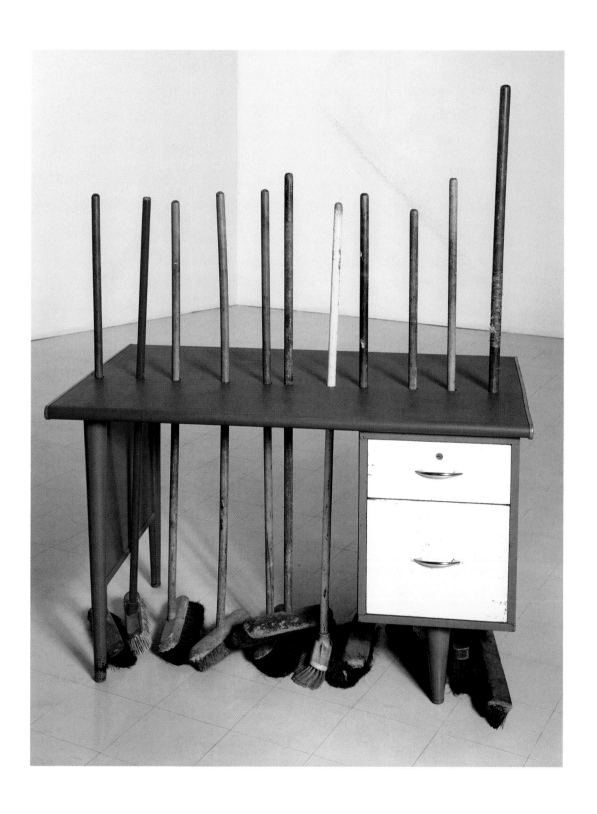

Stile 1991
Steel and linoleum with brooms

Walking Stick 1987
Wood and glass

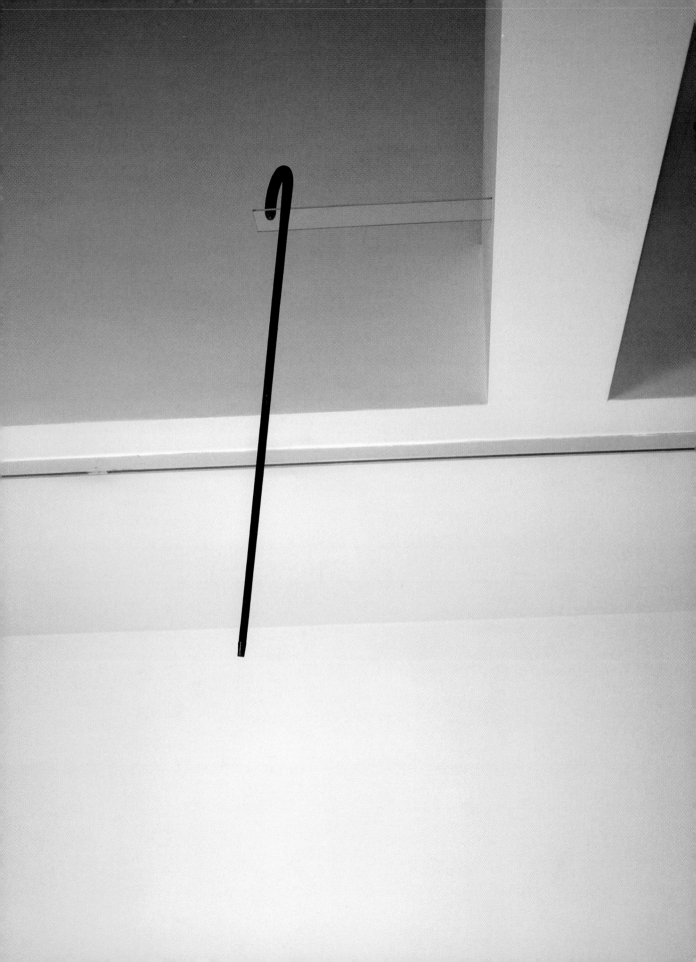

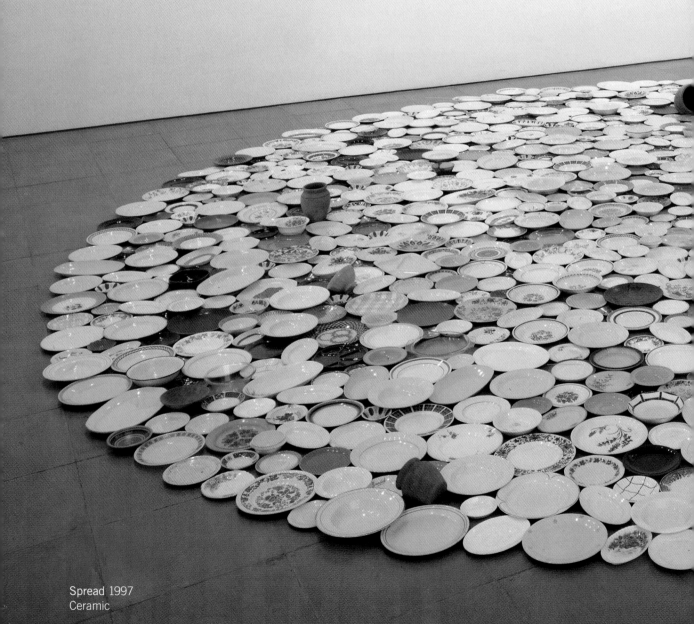

Spread 1997
Ceramic

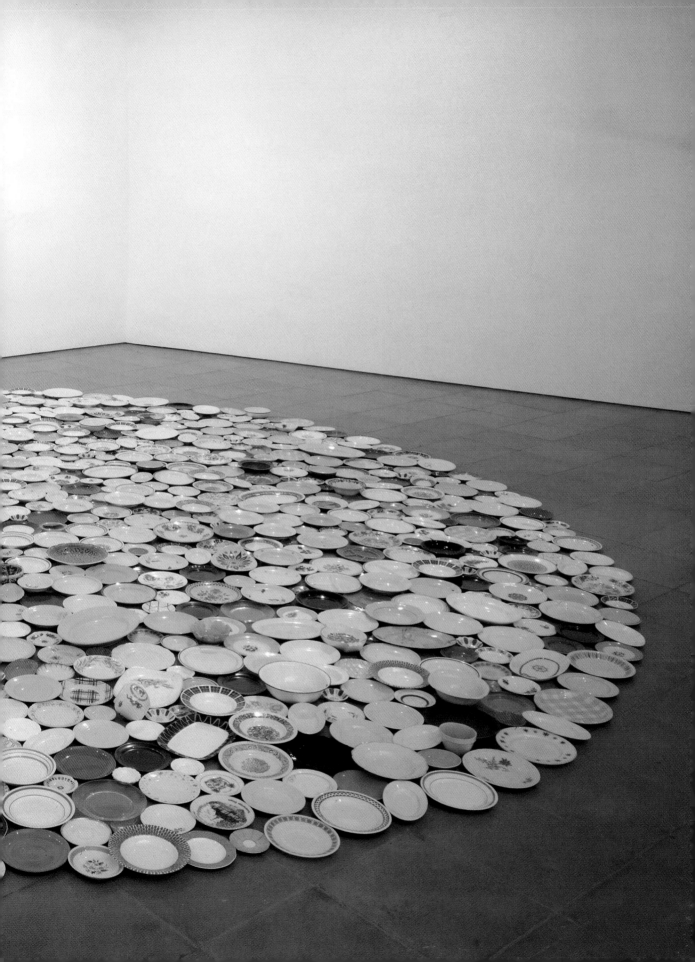

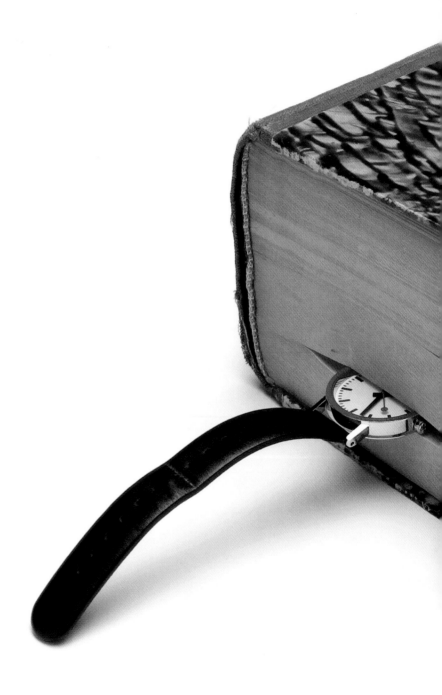

Time and Place 2004
Book and watches

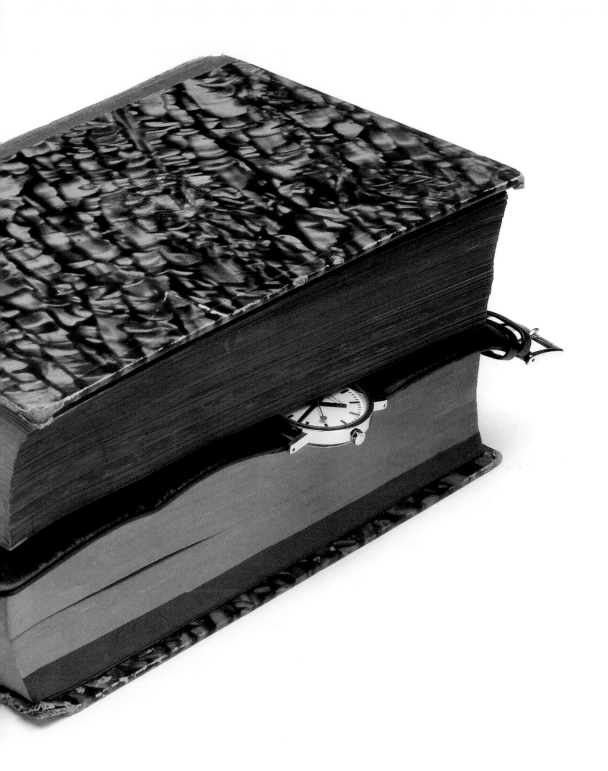

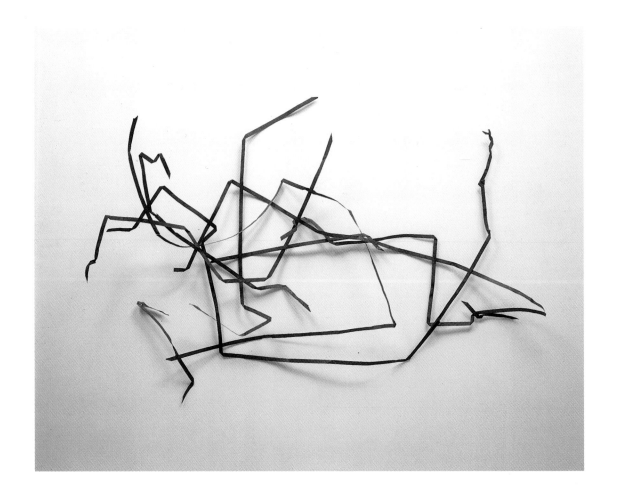

City 1993
Sprung steel

Gravity's Gravity 1997
Wood and cord

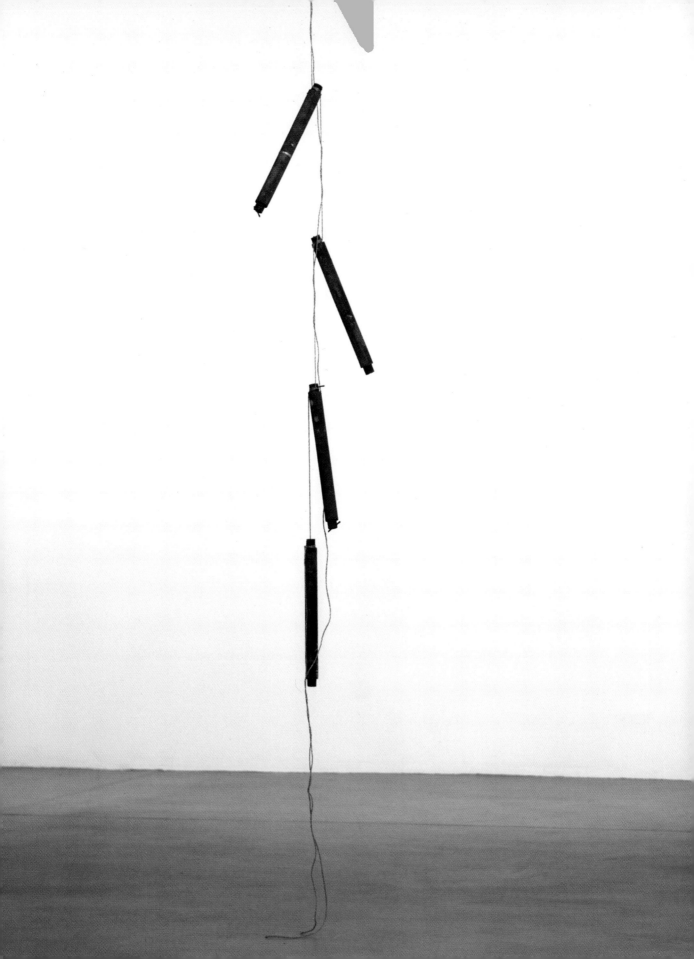

There 1989
Galvanised steel and glass

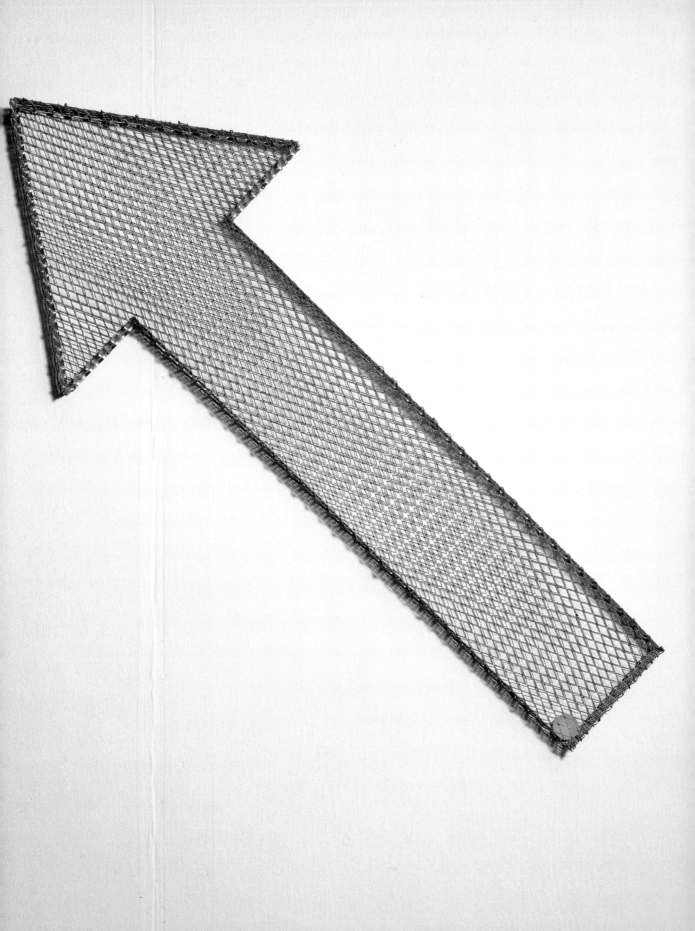

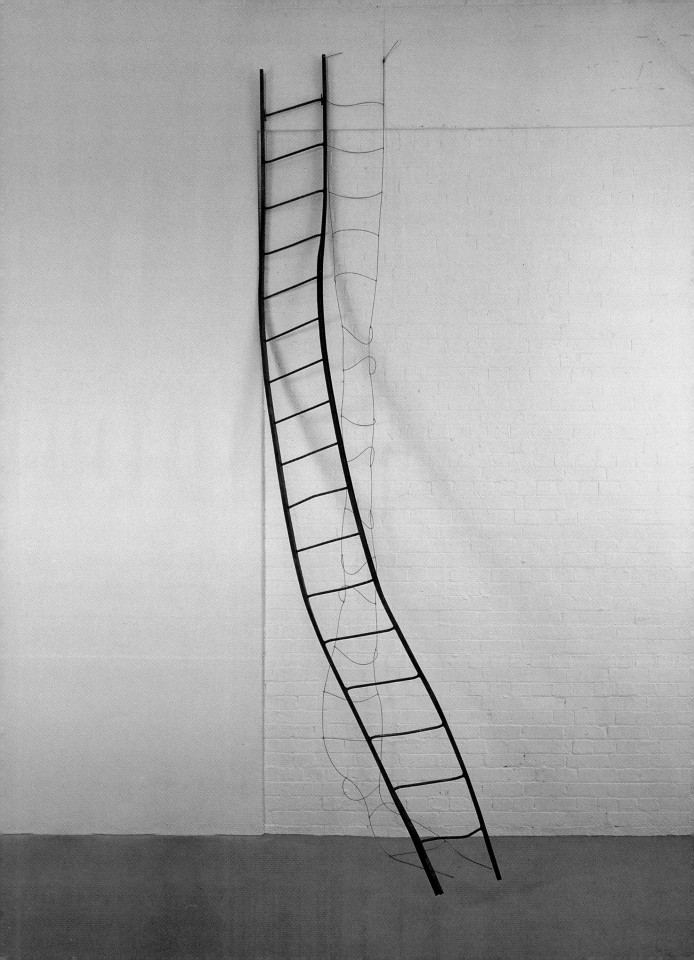

35"9' 32"18' 1985
Steel and cable

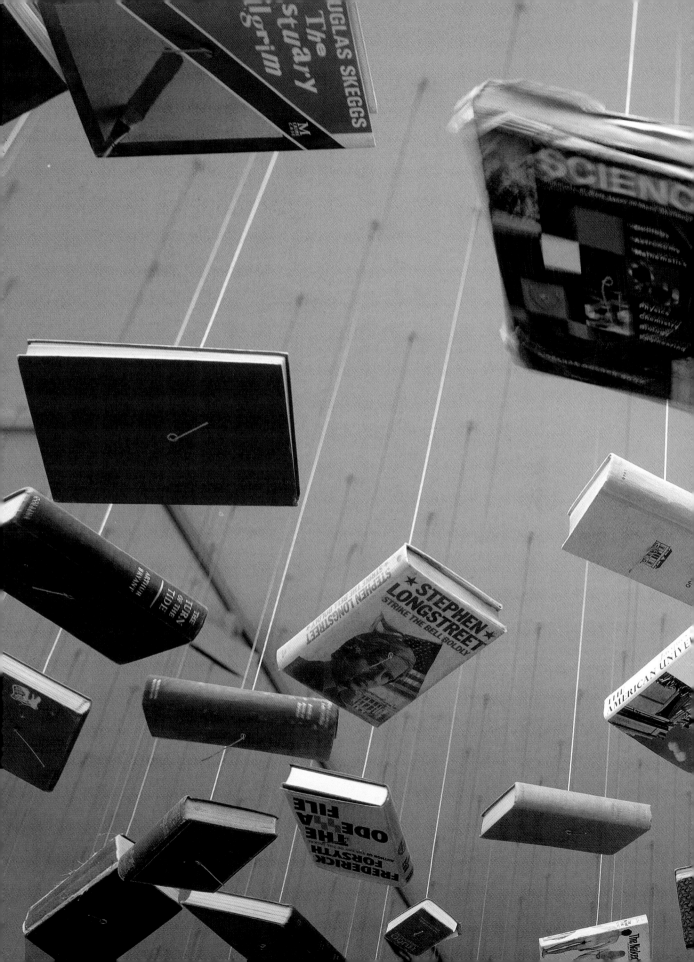

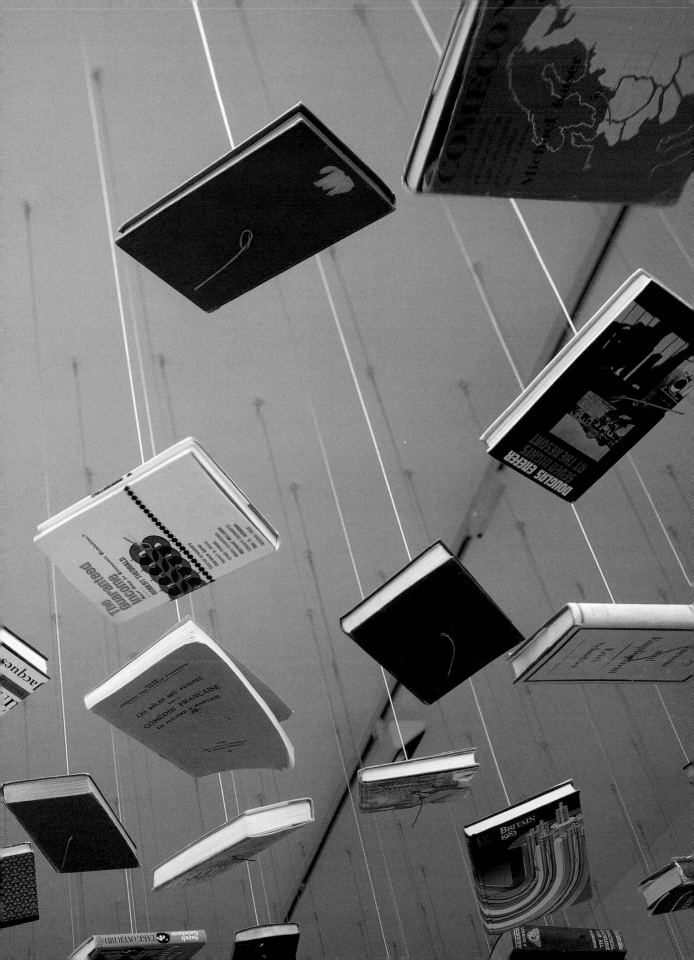

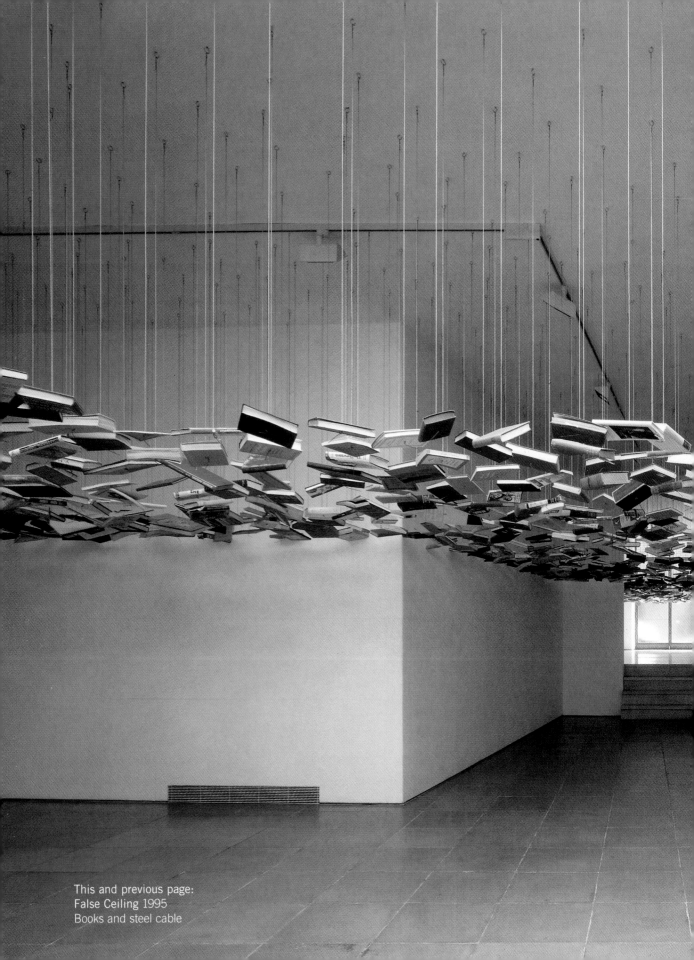

This and previous page:
False Ceiling 1995
Books and steel cable

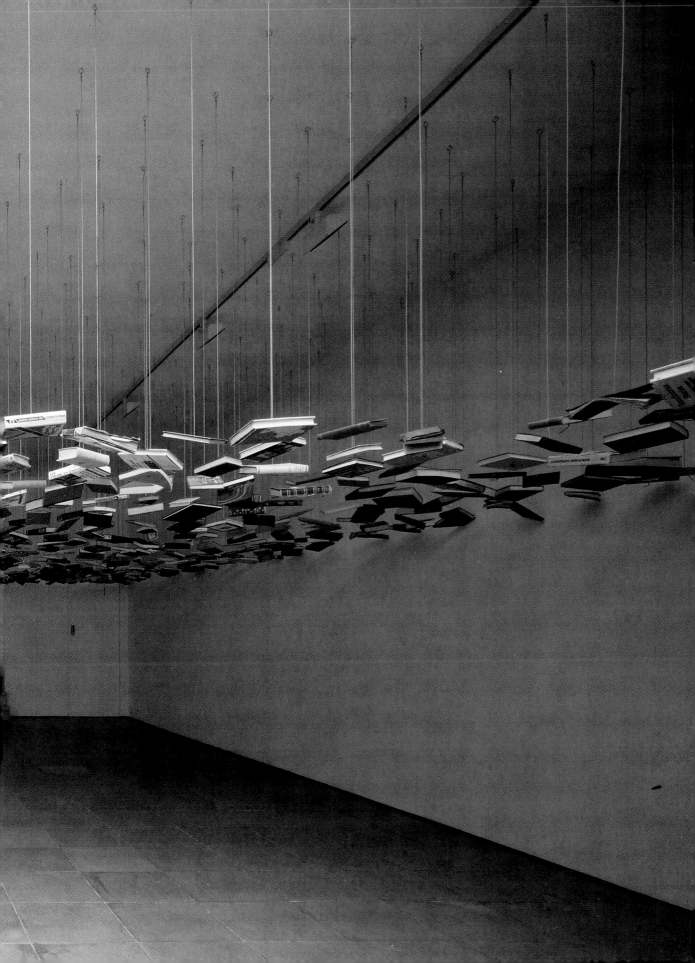

44

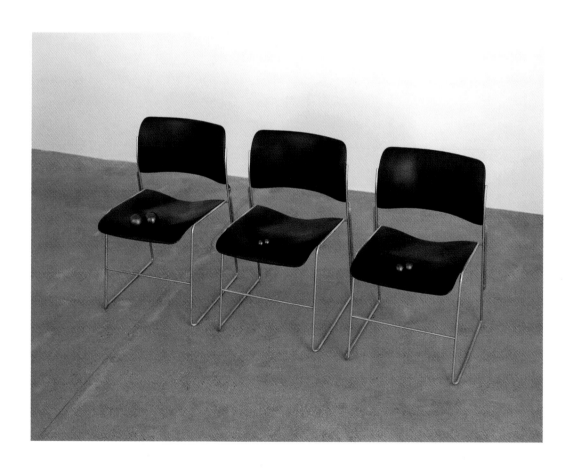

Reservoir 1988
Steel and lead

The Prehistoric Smile

Richard Wentworth, Mark Lythgoe

In 1999 Richard was introduced to the neuroscientist, Mark Lythgoe. Their mutual interest in how people form ideas, and how they evolve and communicate them, led to a continuing lively exchange. The following text has been excerpted from a conversation in November 2004 when artist and scientist met to talk about some of their common ground.

Richard Wentworth So what is an Opabinia?

Mark Lythgoe I wonder if you've heard of the Burgess Shale? It's a land form which holds the fossil remains of many creatures from, I think, the Cambrian era – hundreds of millions of years old. Well, one of the animals that they found was this bizarre five-eyed creature with a nozzle-like snout and claws on the end. They called it Opabinia.

RW You're making it up!

ML No, but what had actually happened was they assembled the remains of some of the creatures wrongly, for example – the stilt-like legs on one creature were really spines! When other researchers realised the mistake and tried again, they came up with a completely different creature. So just looking at things from a slightly different viewpoint made a lot of difference.

RW That's beautiful. But however you put the animal together, it wasn't going to survive?

ML It was probably an evolutionary dead-end whichever way!

RW This whole thing about evolution... Can you say something about our eyes being side by side as opposed to one above the other? And peripheral vision? Why does the stuff at the edge always seem more interesting? Sometimes it seems we're only really creative in the outer suburbs. Is this just psychological or do you think there could be some link with the nature of peripheral vision?

ML Yes, it's interesting. We seem to have evolved binocular vision because that's the most efficient mechanism for seeing three-dimensionally, judging distance and so on. But actually we've sacrificed a certain amount of peripheral vision. There *is* some confusion in the way people talk about peripheral vision: they may say they look at things on the periphery of life, which is a beautiful metaphor for the periphery of the eye, but the relationship *is* just in your head. Physically, the receptors at the side of your eye are more sensitive to motion, so in the periphery of your vision you tend pick up movement, you don't see form, texture, colour. It is still very important though to be able to catch something out of the corner of your eye – it's a survival mechanism. Of course we've taken it one step further and developed our perceptual system. Primitive life forms only have two things they can do: if you go back many millions of years, when you're just a little amoeba, you have these two things – tropism and reflex. So, if the light is the food, the little amoeba goes 'ooh, go towards the food'; if the light is the enemy, the amoeba runs away – that's tropism. Reflex –

RW Like forward and reverse.

ML Like forward and reverse. Reflex means you stab the amoeba and the amoeba recoils. Of course we still have some of this. If I was to blow into your eye, you'd have a blink reflex. You can't help it, it belongs to the reflexive nature we're left with – our bowels, our knee-jerk reaction, those are still reflexive. But being tropic and reflexive is very, very inefficient: what tends to happen is that you catch the little movement in your eye, and you run away. Well of course if it's Grandma coming with afternoon tea, that's a complete waste of energy. This is where perception comes in: what humans have is a highly developed perceptual system. So we make a guess from that movement whether it *is* Grandma or whether it's a hungry lion. And if we're making a guess, that means our brain can imagine many possibilities. Then we make a judgement and decide on one: we either run, or stay. The perceptual system allows us to be more efficient in life.

RW You've written something about the binary nature of the way we make choices – that was brilliant.

ML I think it's really important. Because thinking 'should I stay? should I go? should I stay???' endlessly is pretty hopeless. We must resolve the ambiguity in life, to find a workable solution, even if it is a little makeshift. Make-do events, no-nonsense shortcuts, are what let us get on with everyday living. And our wonderful resourcefulness here is a product of our fertile imagination – an imagination that is uniquely human. A fly has a brain the size of a pin head, yet it has amazing control of its motor and sensory functions, and can avoid our primitive swipes with ease. Our own disproportionately large brains allow us to imagine numerous fictional possibilities and, more importantly, to then choose the one we want.

And something else comes in here, another layer – a gestalt, our need to group objects together in a larger aesthetic. An ability to group things into a whole from very limited information is an inherent part of our perceptual system. Say you are in a forest late at night, and detect a vague movement among the trees ahead. Friend or foe? If you guess it's friend, based on the limited information, and choose not to run away, you will be rewarded with that 'ahh' or 'wow' feeling when they appear out of the trees and you recognize them fully. That feeling is like a little reward for getting it right, and actually comes from your brain generating a few chemicals, giving you a buzz, a little rush. And this repayment encourages us to remember a good move or ingenious act, just in case we might need it in the future to help our survival strategy. Neuroscientists believe that memories linked to positive (or negative) events are far easier to remember and therefore recall for future use. That little biochemical hit is telling you 'you've done really well, do that again the next time'. So a lot of the by-products, the reward – when we enjoy art and things like that – is effectively the brain reminding us that we are doing well from a survival point of view.

RW When you wrote about this, it seemed as near a metaphor for an orgasm as I've ever read.

ML Yes, I think it is. There's lots of ways our brain uses the chemical hit. Fixing the good move in memory is important, because actually we are designed to forget lots of our memories. We've evolved systems to lose memories, because if we retained everything we'd go crazy. But it's important, of course, if we learn that fire burns, that we don't have to relearn that and relearn that and relearn that. So there's a chemical hit that's associated with certain events – happy or sad or frightening or whatever – that's again the brain reminding us to remember that one lesson.

I think this is very pertinent to your photographs. I remember that picture you took – *Islington, London 1976*, with that old sheepskin coat being used as a makeshift car wing. Those pictures make us smile, don't they? I think that's because when we see people doing ingenious things we admire that, and it's lodged in our memory with that 'aah, yes', in case we might draw on that inventiveness again in some future fix.

RW That makes sense to me – the way noticing becomes memory.

ML Yes – because, it's laid down in our genes from way back. Lucy, our most well-known hominid ancestor, is around three million years old – *millions* of years! But it's likely we've only had language for just a tiny fraction of that, at most a few hundred thousand years. For *many* hundreds of thousands of years, we've been in the environment with the sun in the sky, the wind blowing across us, the trees growing in the same way, creating fires in the same way, and all these things were incredibly important to us. They've left their imprint on us. I think it's suggested that, certainly when artworks are created to represent let's say a landscape, they're tapping into that 'environmental module' in our brain, that prehistoric link we have with our environment which is so crucial.

RW And now we've evolved this big brain which, as you say, can fictionalise...

ML You might say, well maybe our intelligence resides there, in that large brain. But many animals are also intelligent in their way. But it's the ability to imagine, to be able to imagine the world in lots of different ways, which embodies our creativity, our ingenuity. I don't think that a fly can imagine lots of scenarios, it just reacts, it's very reflexive, and it's very good at being reflexive, that little brain. But, for us it's our imagination. And the extra brain size allows us to be able to create these different scenarios.

RW Something happened that was more than just about our survival. We got this spare capacity and we survived a little bit better because we were rehearsing all these possibilities. Then maybe we get to a point where we can use those possibilities in an almost playful way, which I suppose would be like if once you've learned to walk, you would discover that you could dance.

ML This is a good point. So we get this extra bit of brain and what else do we do with it, beyond just survival? We start to go dancing, to create paintings, music. But why would we waste all that energy – because we're not designed to waste energy whatsoever – on these biologically wasteful tasks, such as artwork? And some people might say in fact it is a complete waste of time, it doesn't help us, from an evolutionary point of view. But I support the notion that this is where the brain, like the peacock's feathers, is

a sexual ornament. There's reasonable evidence to suggest humour, wit, intelligence, imagination, are factors people look at in assessing compatibility. And of course artwork is an expression of your capacity to be able to imagine, and then to represent the quality of your genes. So the brain may effectively be a sexual ornament. Your sculptures are just an extension of your penis, that's what they are.

But of course it's interesting we only developed language comparatively recently, and, perhaps more than coincidentally, artistic representation, both of which depend on an imaginative use of ambiguity. And both constitute a symbolic use of signs to communicate, and an imposition of symbolic meaning on reality.

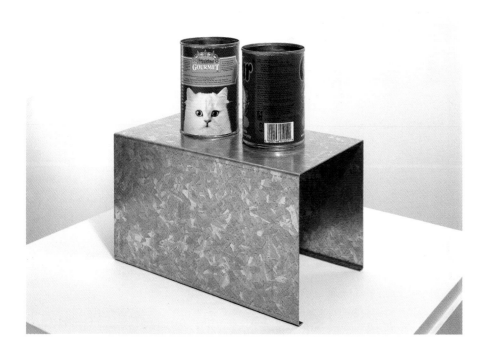

Man and the Animals #2 1991
Galvanised steel with tins

RW What about 'disinhibition'? That's a special interest of yours?

ML Well, disinhibition is a new notion that I've been trying to bring to artwork. Psychologists have been talking about disinhibition for decades. And neuroscientists usually talk about it in terms of physical damage to the brain.

RW And chemical imbalance?

ML Yes. A person may become disinhibited following neurological damage or a change in the brain chemistry. We have these two pathways in the brain: inhibitory and excitatory. And they compete all the time for every single emotion, every thought, everything we do. So what happens is, if part of the inhibitory pathways becomes damaged, for whatever reason, then the excitatory ones would come to the surface. A person would have a massive personality change – become verbally aggressive maybe, and dreadfully irritable beyond his control. But we have these pathways in many parts of the brain, and hence we come to the notion of disinhibition in artwork. I met this chap, Tommy McHugh –

RW He's someone you've actually worked with?

ML I've known him for about two years. We've just written a paper about him for the *Journal of Neurology*. The title is 'Obsessive Prolific Artistic Output Following Subarachnoid Haemorrhage'. It's the only case like this reported in the world. Tommy always describes it in terms of something bubbling up to the surface. He can't control it but he has all these associations, wonderful, interesting, exciting associations that are taking him in all different directions. So many people in this world are trying to find new ways of being creative, but some people are able to do that automatically. It just seems they don't have the filters that the rest of us have.

RW But are those filters social?

ML I think so, yes, of course. When our thresholds where we decide what is socially acceptable or not acceptable are defined culturally, completely culturally, and what we have are the pathways in the brain to be able to define where those thresholds lie.

RW So that's a map?

ML That's effectively a map. The brain is able to map out where those boundaries lie. And then they're imprinted within our brain and we can apply them to various situations. Some people don't have those thresholds, or their thresholds are in a different place, and are not defined socially and culturally. Take people with Tourette's syndrome –

RW Tourette's syndrome is a huge umbrella – it's not just people who swear a lot?

ML No, in fact there's a suggestion that people with Tourette's are incredibly creative. But they find inhibiting certain action very difficult. And they're sometimes driven to do things that are outside the social norm. So they don't have the same threshold; their boundaries are a little bit further out. Now of course this can be incredibly productive, and in our society I think we're trying to look at people with different brains in a more flexible way. Just because your brain works slightly differently from someone else's doesn't mean you've got brain damage or that you're disadvantaged in any way. Tommy McHugh is probably the greatest example of this: this is a guy that *has* had some

damage to his brain; he's got a completely new personality; he's lost his wife, his friends... but gained a lot. And he says he would never go back to being the old Tommy. He prefers the new Tommy. That's the remarkable thing. This is about identity. What defines you as an individual? Is it the clothes you wear, the way you look? Presumably if you change the way you look you still *think* the same. But what happens if you think differently? Are you still the same person? I think we clutch onto our identity very much. If there was more of a fluid interpretation of identity, we'd be a lot more open to the idea that changes in our brain chemistry are a good and positive thing to look at, because they do allow us to do things that we wouldn't normally do.

RW Where does 'normality' come into all of this? Because – it's very interesting – the more you say, the more political it seems.

ML Yes, it is.

RW I'm actually slightly trembly about how society decides what's normal, and what's not normal, and what we do to people who we say are not normal, or less normal; how the society regulates itself in a way which of course is the big model for how we regulate ourselves; when we fart, or don't fart... And this rubs up against the kind of open territory that's always proposed by art. But then art is never as open as people propose it to be: there's still the idea of this expressionist space, wild people and what have you, but you don't have to meet very many artists to know that it's not like that at all.

ML Can I put this another way: let's say if I was to suggest to you, not that you've got in any way brain damage, but that you have similarities with Tommy or other patients. All I means is, there's a change in the biochemistry of your brain; for whatever reason, your brain is different. There's no doubt in my mind that your brain *is* different to mine, and thinks differently. You are one of the most disinhibited people I know! There's two ways I'd say this. One, you're disinhibited because you move from topic to topic to topic very, very quickly, all over the place, spontaneously, and you make me feel I'm on some kind of helter-skelter trying to keep up with you. Then, also, you have this element, that when you talk, it *is* slightly outside what we might call the social norm; it's this constant stream of disinhibited notions and thoughts and new associations that are coming in.

RW Well, one of the things that all this is inducing in me now is an absolute storm of ideas! So while you were speaking I was thinking, oh, is that like architecture? You know, you can walk down some streets and you could say, well, they're all buildings, but actually they have incredibly different meanings. It's actually very interesting with very young children to walk along and say, 'What are all these?', and they'll credit some as being houses, and then they'll come to one and say 'it's a police station'. One of the things I taught myself to do and how I like to investigate a city, is to ask what something is *not*, not what something *is*.

ML It's interesting when you talk about kids, because it's suggested that kids think a lot more in images, whereas as you get older, you lose the ability to think in images.

And of course children are a lot more disinhibited than adults. You know, their social thresholds are completely different. I think it was Einstein said that we should be able to remain thinking like a child, or he thought like he did as a child, meaning he could think in images. And in some respects because of that, he was more disinhibited, so maybe we need to latch onto those ideas, to think like a child.

RW I was with my eldest son recently, and it was like having another brain glued on. He alerted me to so many things! A very simple thing, almost as we started: we were at the back of King's Cross and there was some of that galvanised railing – the really primitive and aggressive kind with the three-spiked top, the harshest kind of 'keep out'. And it had been parted by some means, accidentally on purpose. This revealed a piece of the structure behind, which is actually the site hoarding for building the tunnel for the train from Paris. So there's a parted space, and in that space one of these smart young kids had done a stencil of a running man. Now the little running man couldn't fit in any of the regular gaps in the fence. I adore that stuff; that is at the edge of art, that little running man.

ML You smiled then. You gave that little smile as you said 'that little running man'. That smile – it's recognition. You see something and you get that little chemical hit each time, don't you? What's remarkable is that when I see your photographs, I get exactly the same response. You're tapping into something that's at the core of every single person, and I think this is what's at the core of being human, the human condition. Because I know that every single person I've sent the photographs to – they all smile.

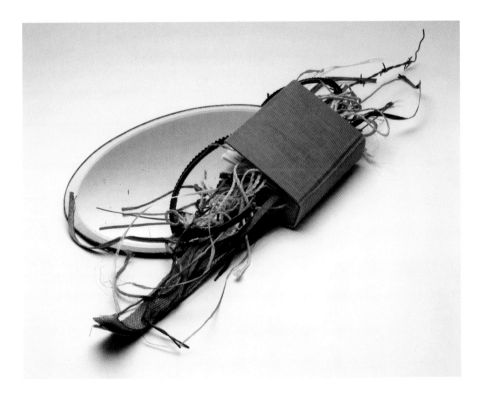

Width 2004
Book, looking glass, string, steel, rubber and plastics

ML Can I ask you about the language? It's about the sculptures – they're just so different from the photographs. With the sculptures you've got this heavy top-down, or head-referenced, component where you relate the semantic to the perceptual, the verbal to the visual, which makes me feel sometimes I'm on a puzzle, and I'm trying to resolve it like a game. Sometimes, I'd look at the sculpture and I wouldn't look at the title, but of course as soon as I'd get one notion of what it is I'd look at the title. And sometimes I'd think, 'Oh yeah, I'm actually pretty close', and sometimes it would take me in a completely different direction. Sometimes they're so far apart, the jump, the journey that you've gone on between the semantic and the actual creation of the sculpture, the visual, is huge. And that journey sometimes for me is a leap too far, and I've ended up at a completely different place from the one that you have.

RW Can I just say: they're absolutely not conundrums. I think they might borrow from the idea – I think you've taught me – that they might operate in this binary space, but I suppose my wish for them is that their potency would be in their ability to be imagistic. It's somehow like having grit in your shoe – it's amazing how long you can keep something in your shoe and keep accommodating it and moving it around. I think the way they get titles is closer to the way you might name a child. It might be a kind of rhyme with or echo from the piece, like onomatopoeia. You could say the title is a nomination. But also, I love the plasticity of language, which is dealt with brilliantly i n *Blackadder* when Baldrick uses Dr Johnson's dictionary manuscript to light the fire and Rowan Atkinson says, 'Where is Dr Johnson's book?' and Baldrick goes 'Book?… Oh, you mean the black and white papery thing? It's in the red, flamy, hot place'! And of course it is to do with, when you look up in a dictionary 'fire', it says, you know, 'conflagration'…

ML Well, this is where words are all just approximations.

RW Precisely. And we've had to develop points of agreement as to what we call things, what the approximations are pointing at. Sculpture can sidestep all this.

ML Yes. And of course the way we view the world is very much culturally based. Like perspective: we learn perspective through straight lines in Western culture, whereas people that don't have straight lines don't learn perspective, or learn perspective in a different way. I interviewed John McCarthy after he'd been held hostage for so long.

RW How soon after?

ML It was several years, but what was interesting was, he told me a story that when he went into a field and saw two cows, he saw a big cow and a little cow. He didn't see a cow close to him and another cow far away; he'd lost the ability to see perspective. He'd been in this ten-foot-by-ten-foot square room, and because of that he didn't need to use perspective any more, so he'd lost the ability to see it. And then I remember Robin was telling me that when she was in the jungle, she first had to go and find these tiny little insects, beetle-like things, and for weeks and weeks she just couldn't see any; then eventually she clicked into that way of seeing, and suddenly she could see beetles

everywhere. And I think this is what you've done. You've honed your visual system to pull out something that we all have a connection with – not simply from our own era, but actually a lot further back, from our evolutionary past. And I think this is what makes great art: someone who can see something that we all can relate to, that universally lights up the same area of our brain. That's what your photographs do for me.

RW I want to hug you! But there's a punchline, a really lovely punchline, which is that Richard Gregory, when I had to interview him in Bristol, said, 'I take a lot of photographs myself, but there's really no comparison whatsoever, your photographs are marvellous, *marvellous*. But I want to ask you something.' Then he said, 'If I had some really nice frames made, and we went round the town together, we could lean them on things.' – the empty frames – 'Wouldn't that be the same thing?'. Well, it's a very beautiful, mad, late Surrealist image. But of course I wanted to say 'No of course it fucking wouldn't!' Because actually, the world is framed, it is *highly* framed, in our culture; there are lots of 'paintings' on the street, but they're called signs, posters, shop windows.

ML I would disagree: I think he's right to suggest that putting the frame round things is very similar to what you do. Isn't he?

RW Well, he's right and he's wrong. It's a lovely idea but it depends on who's doing the framing. Of course there are all those questions – scale, point of view, distance...

ML ...and medium and fall of light. But can I just ask you one last thing about the sculptures, because I think the semantics are really important. Do your sculptures work without titles?

RW Absolutely. In fact I rather object to the fact that I title them at all.

ML *Really*? I'm shocked that you would say that.

RW I don't ever work from the title –

ML No, I'm sure you don't. I'm sure that you work with a sculpture, on this journey that you go on, then you have this word that – I can't even imagine where it comes from, because I'm sure it's a different journey each time and you arrive at this word. But for me they would be completely different, those sculptures; you would look at them completely differently without their titles, they wouldn't be the same sculptures.

RW What I mean is, I sort of resent my own education... The difference in me between the bit of me that is agrarian, the bit that actually perhaps feels like a Mediterranean person, and the bit of me that is a northern European rationalist, thoughtful, got quite a big vocabulary, is interested in etymology, no scholarly qualifications whatsoever but pretty damn nosy and looking stuff up all the time... I get nervous about the bit that is, if you like, 'educated', in relation to the bit which is almost like liking having my willy stroked. I love digging in the ground; I know the weight of things just by looking at them; I'd know the gauge of a piece of sheet metal, say, at a distance of thirty yards, and how much pressure it would take to bend it.

ML You're an earthy guy, aren't you? Quite an earthy guy at the end of the day.

RW Well, haptic, maybe. I need to be able to touch things. So those two things – the

agrarian bit and the verbal, educated bit – are doing something. That's my own take on it.

ML Isn't it interesting: for me the most intriguing thing is the tension between your evolutionary roots – whether out in the environment, the trees, the garden, the small efficiency that we have – and this education you've had superimposed on you. These are constantly coming into conflict. So you have these very wordy, semantic titles, which reflect your education; and then you've got this hands-on sculpture that you've built. And then you say, yes, you can take the title out and that's it! Of course, that's you, isn't it, that *is* one side of you. But then the other side of you *is* these rather provocative titles. When you actually know you, you can't have one without the other.

RW No, I think that is true, and that is a little bit like, you can't ask for a cup of tea without using the words 'cup', 'of' and 'tea'; and it doesn't happen otherwise, unless you start pointing.

Richard Wentworth and Mark Lythgoe wish to dedicate these discursive explorations to Professor Richard Gregory as a mark of their admiration.

Template for Politicians 1994
Sprung steel

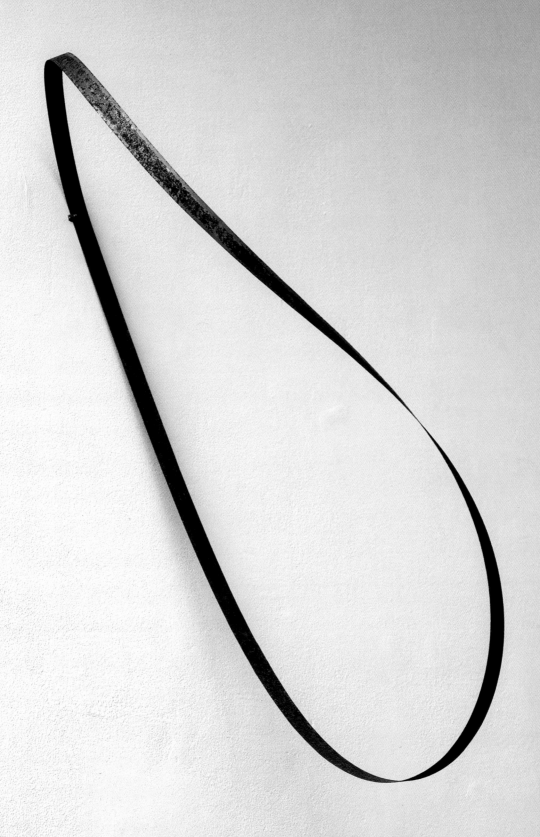

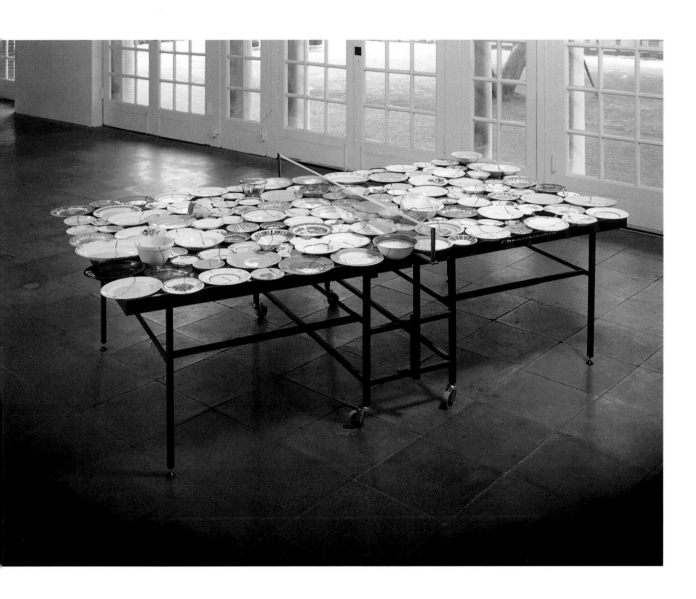

Match 1995
Ping pong table, porcelain, earthware and epoxy resin

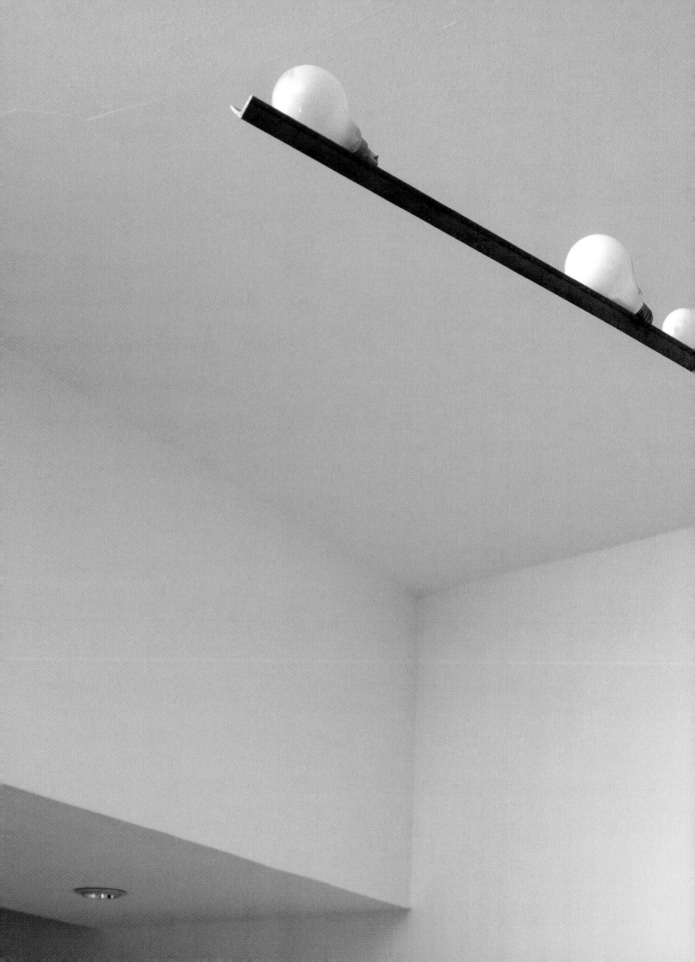

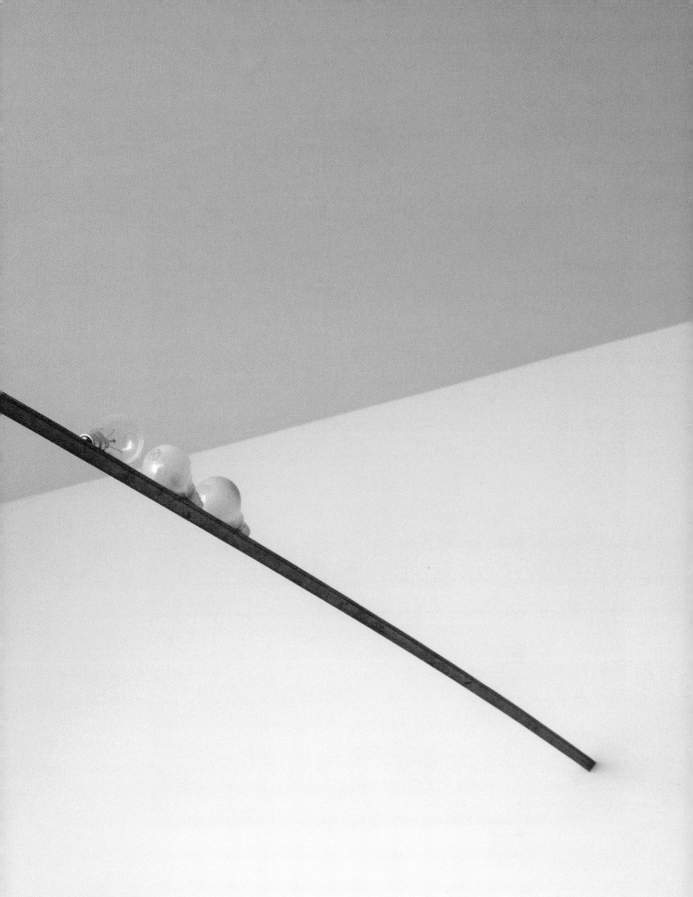

Salute 1999
Steel and dud light bulbs

60

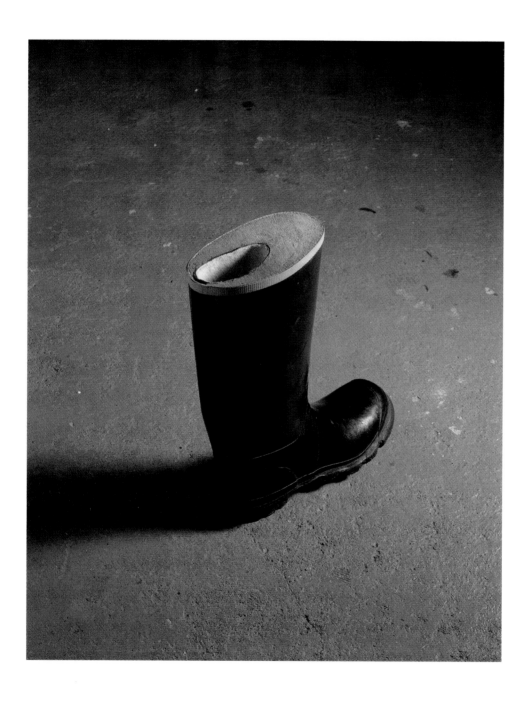

Guide 1984–88
Rubber and concrete

English Sandwich 1988
Glass, wood, felt and looking glass

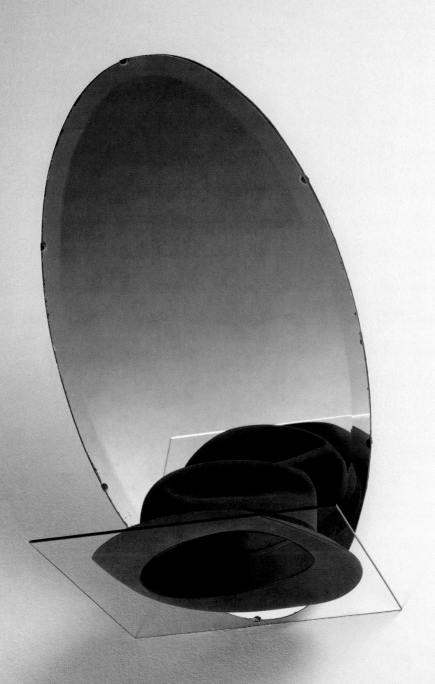

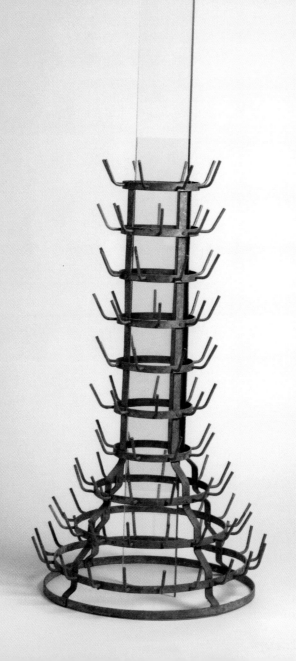

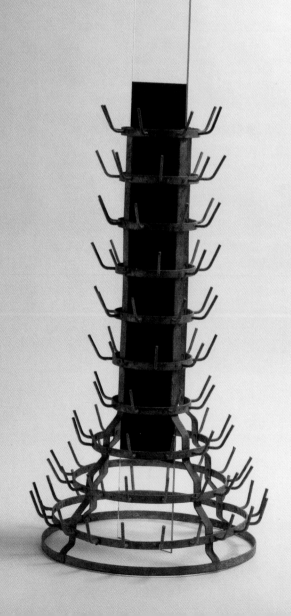

This and previous page:
'If only' 2004
Galvanised steel and mirrored glass

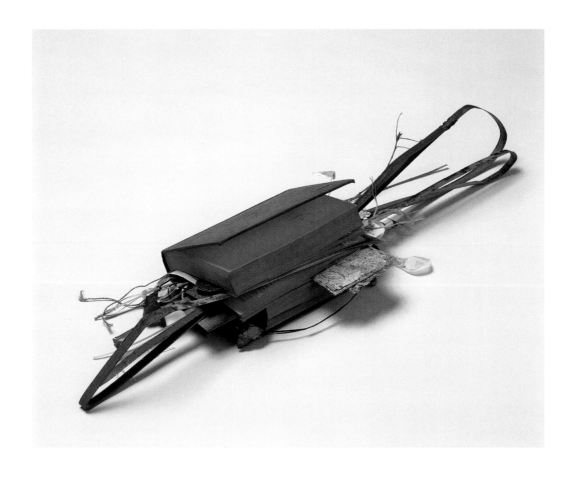

View Across A Border 1997
Book, string, steel and plastics

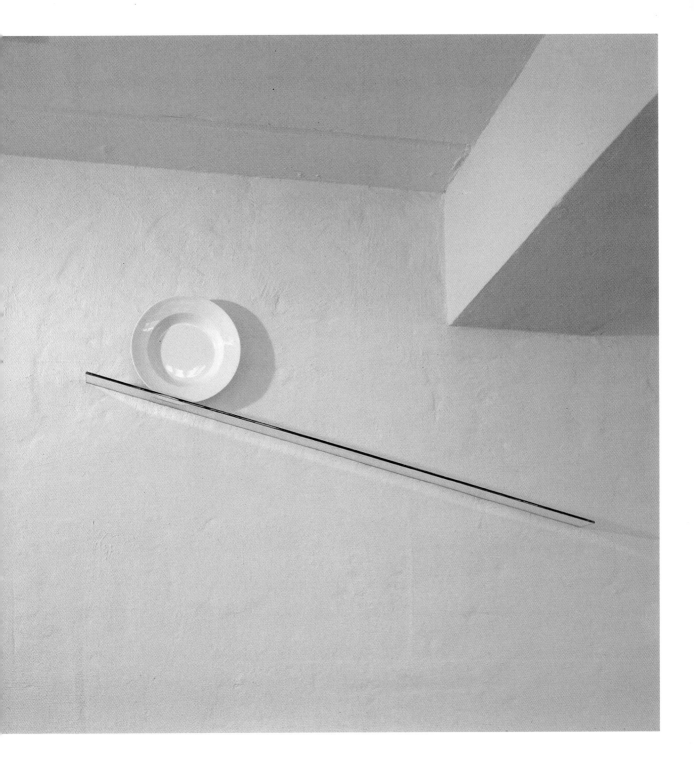

Stonehenge 1992
Glass and porcelain

Balcone 1991
Steel, linoleum and tools

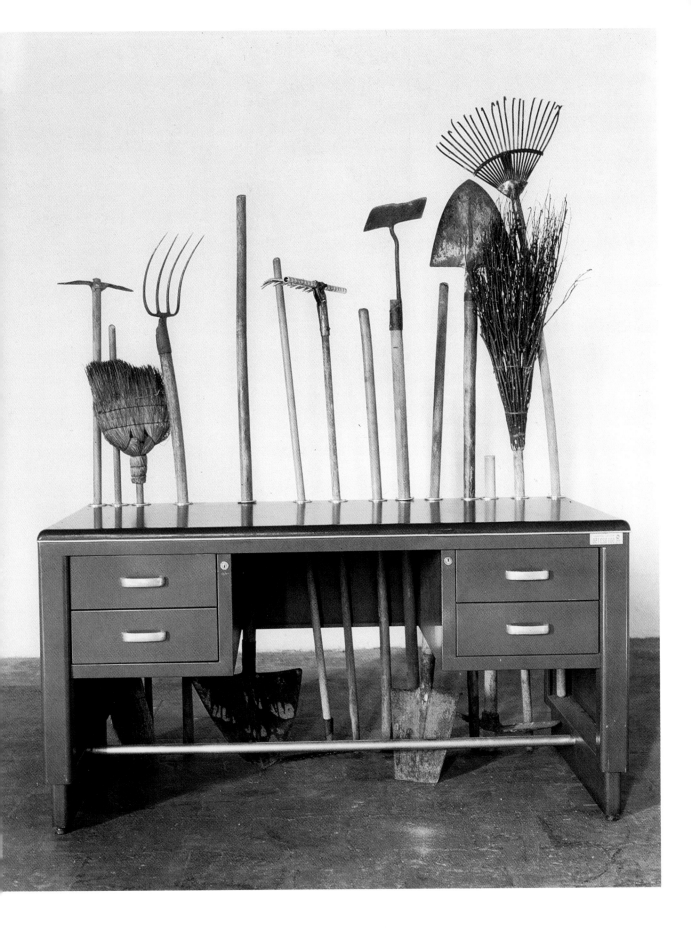

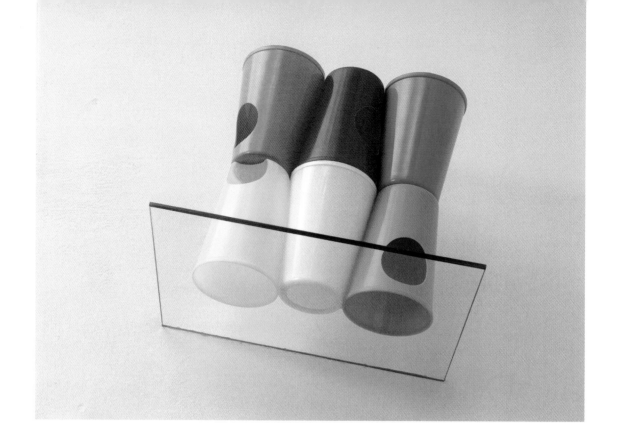

Late 20th Century Flag 1993
Glass and plastic

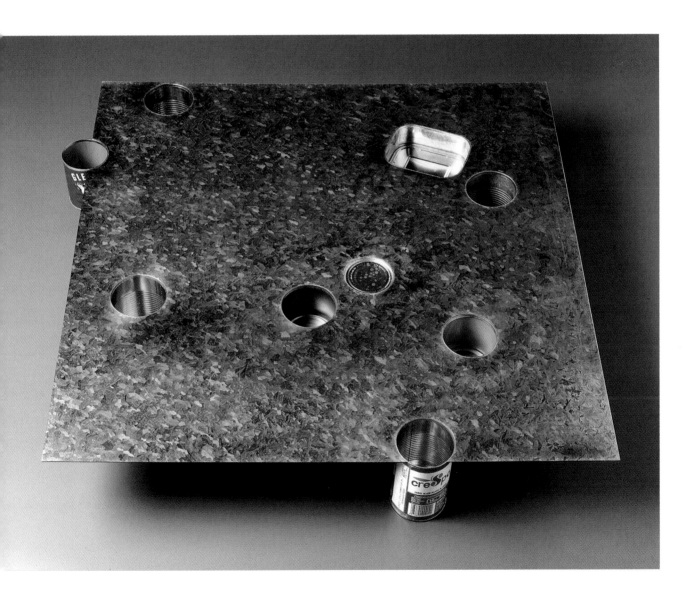

World Soup 1991
Galvanised steel with tin cans

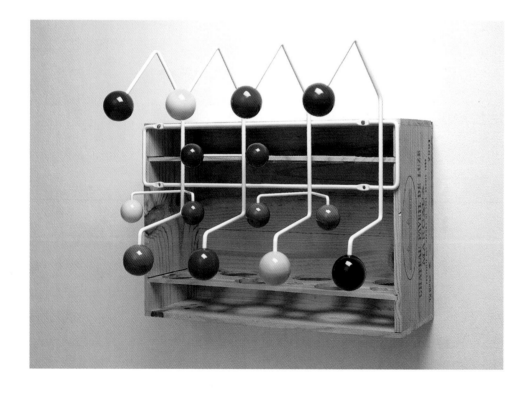

Mode-Module-Modulor 2004
Wood and steel

In Medias Res

Simon Groom

A simple walk down a street with Richard Wentworth can be a vertiginous experience, a reminder of all the ways that we normally fail to see the world. It is typical of the artist to spot, for example, the '-gland' on a limp St George's cross when over-familiarity with the thousands of identical flags hanging from windows all over the city would have made anyone else automatically prefix the fragment with the hidden 'En-'. And of course, once the connection has been revealed, 'thinking of England' can never be quite the same again.

Wentworth's work comes directly from this rare ability to see anything and everything as if always for the first time. Such a way of seeing is a way of interrupting the habits with which we view the world, to go beyond what Wentworth has called 'the ready-mades of the imagination'. It is for this reason that one suspects that he instinctively distrusts institutions, or forms of authority that masquerade as knowledge, intent as they are on creating monolithic versions of culture. Rather, he deploys facts as he does the ready-made objects that make up many of his sculptural works, in unexpected and quirky combinations, so that they always act as new points of departure, inviting other possible configurations of the real. In much the same way you could imagine philosophers collecting stones in the Middle Ages, not to confirm a thing but to transform it into something strange and rare. The utopianism can be heard in the 'What if…' that is one of Wentworth's favourite opening phrases.

His interest in transforming the world comes from the simple recognition that the world has itself been constructed and transformed by others. Nowhere, of course, is this more true than in the city, a place of anonymity where not a centimetre has not been orchestrated by the human hand. *Making Do and Getting By* is the record his encounters, of an awfully long walk over the last thirty years or so through familiar streets: a photographic celebration of untold thousands of ubiquitous 'invisible' sights. 'All this is man's space; in it he measures himself and determines his humanity, starting from the memory of his gestures'[1], as Roland Barthes wrote of Dutch still-life painting, of which the city is in many ways the contemporary equivalent.

Similarly, the objects Wentworth often brings together so surprisingly in his sculptures suffer the same form of displacement that the objects of his photographs do by being recorded, resulting in an estrangement that makes us look at familiar things through new eyes. There is a continual oscillation between the form of a thing – the rhyming of a ladder with a strainer, say – and the use of a thing, often for an end different from that originally intended: a chair to prop open a door (but which ends up barring the very entrance it promises), for example; so that the obduracy of a thing gives way to the mutability of a thing. The public world of objects is approached with the singular eye

of the artist not to reveal associations personal to the artist, but to tease out in public something more of the private life of a thing. The sculptural works themselves often give the appearance of being self-sufficient, closed, enigmatic, a question thrown back into the world, an object richer and stranger precisely for seeming at once so familiar.

A large part of this uncanny power derives from the fact that, as Wentworth himself might disarmingly say, he doesn't do much to quite a lot of things. But this 'not much' conceals a considerable amount of thought, especially for craftsmanship, which is intelligence made manifest in things. From another mouth this could sound like nostalgia, a lament for the way things were, a fondness for terms to describe technical processes now no longer used, or tools whose names are no longer currency, poetic in their redolence of an era and knowledge past. But with Wentworth, one understands that he really cares about the things that surround us, their history, and our interaction with them. In a fax from Wentworth (faxes, along with postcards, being his preferred means of communication, increasingly complemented by the gnomic text message: 'Tsingtao (beer) is a German word', 'Bosphorus means ox ford'), his sheer admiration for the radical architecture of Jesse Hartley, responsible for the building in which Tate Liverpool finds itself, completely outweighs the evident difficulties any work will have competing with it: 'In spite of your "realist" tease', he writes, 'I just *love LOOKING* at that radical roof.'

The 'architecture' of his sculptural work is meticulous, the juxtaposition of objects as considered as the comparisons of a metaphysical poem. The initial smile of recognition in the conceit of a pairing, however, is often swiftly followed by a nervous laugh, as joy in the unlikely coupling collapses under a further torrent of questions: What are these things doing together? What is its status now as an object? What does it mean?

The new positions, roles and identities assumed by these objects, even when anonymous (as in the photos), point to a form of exchange – in identity, in labour, in the human and social interaction that brought these objects into being – that is a very sophisticated reflection upon Wentworth's belief that all we ever do is 'convert the stuff of the world into other things'. That this transformation operates at the level of the everyday is not to belittle its significance. Wentworth's way of working rejects the monumental in favour of the neglected, the overlooked, the taken-for-granted, the manifold coincidences and tiny gestures that constitute the texture of the everyday. Removing an object from its habitual place in the world is to restore it as a thing, and to rescue it from the humiliation of homogeneity. It is also to acknowledge the democratic understanding that culture is produced mostly anonymously.

If anything, the more intensely the artist engages with these minutiae the more thoroughly radical his enterprise, aimed at nothing less than a workaday revolution of the commonplace. That such scale of ambition should arise from such seemingly modest means is part of the paradox that characterises both Wentworth as an artist and his work in general. Just as his work often stages the collision of the wonderful and the

mundane, Wentworth himself appears simultaneously to be one of the most influential artists of his generation yet one of the least visible. Wentworth once described artists as 'highly trained nosy people', and it is something of the modesty and radicalism of such a description that Michel Foucault saw as characterising the operation of curiosity:

> Curiosity is a vice that has been stigmatized in turn by Christianity, by philosophy, and even by a certain conception of science. Curiosity, futility. The word, however, pleases me. To me it suggests something altogether different: it evokes 'concern'; it evokes the care one takes for what exists and could exist; a readiness to find strange and singular what surrounds us; a certain relentlessness to break up our familiarities and to regard otherwise the same things; a fervour to grasp what is happening and what passes; a casualness in regard to the traditional hierarchies of the important and the essential.[2]

Such subversive intent could stand equally as a description of Richard Wentworth's own way of working.

1
Roland Barthes, 'Le Monde-Objet', in *Essais Critiques*, Paris, Seuil, 1964.

2
Michel Foucault, 'The Masked Philosopher' (interview with Christian Delacampagne), in *Foucault Live (Interviews, 1966–84)*, trans. John Johnston, ed. Sylvère Lotringer, New York, Semiotext(e), 1989, pp. 198–9.

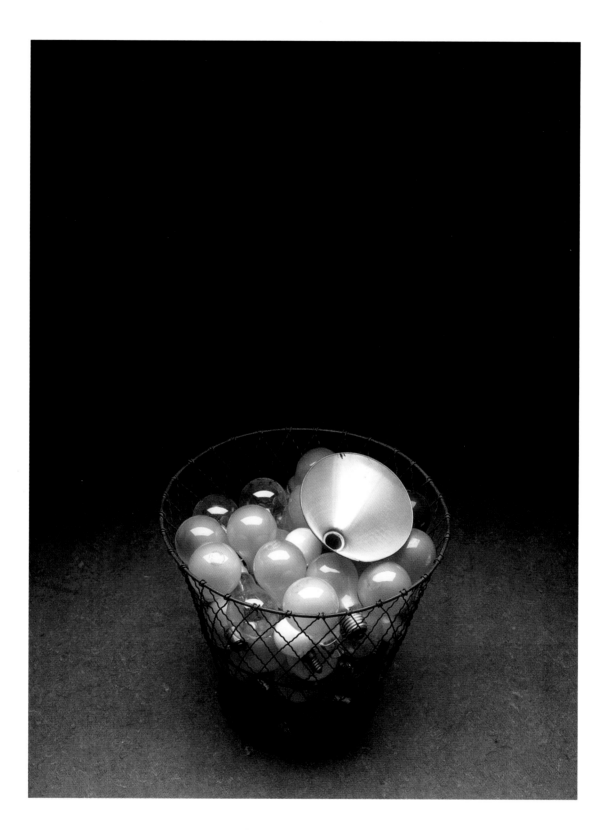

Saving Daylight 1984
Steel with dud lightbulbs

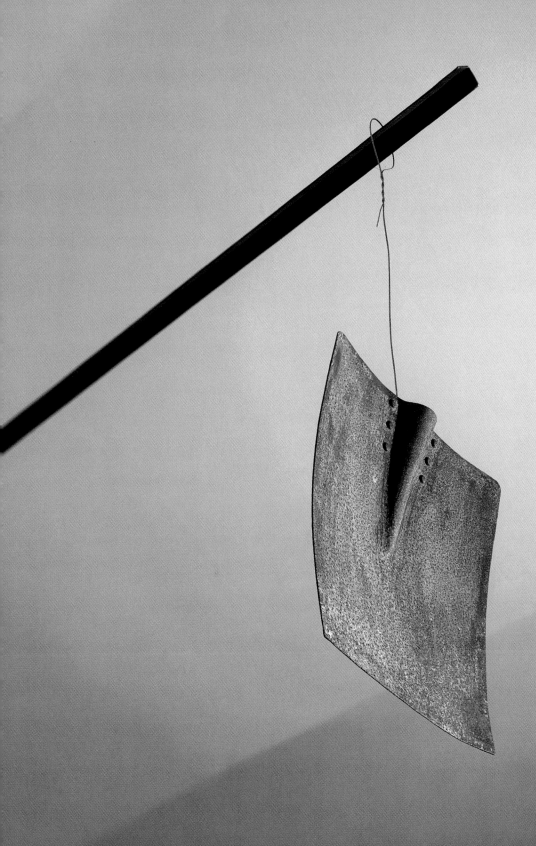

Two Spits 2003 (detail)
Steel, wire and cable

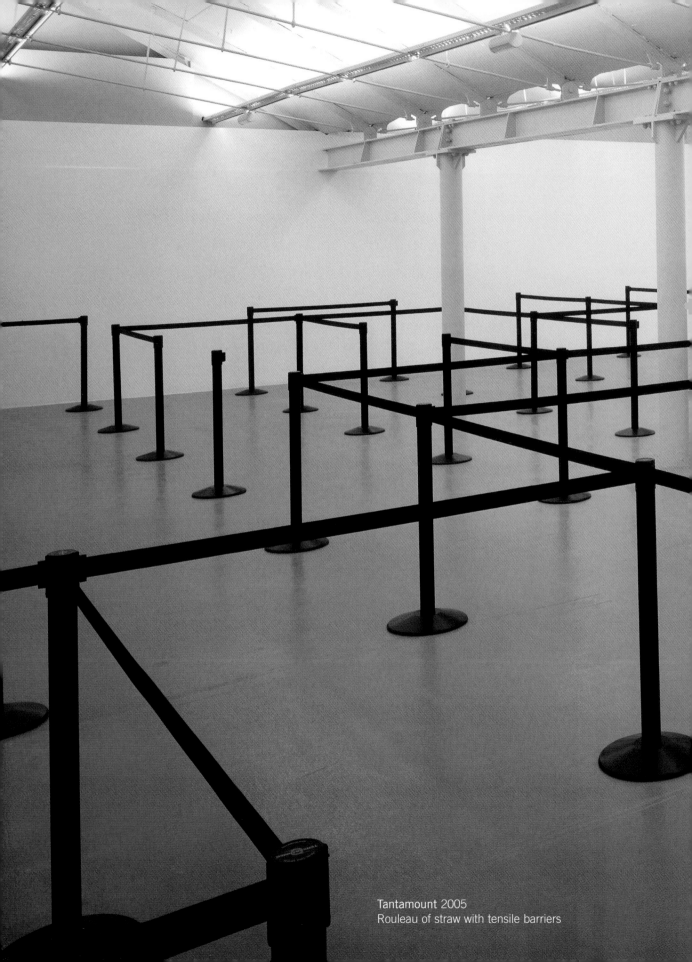

Tantamount 2005
Rouleau of straw with tensile barriers

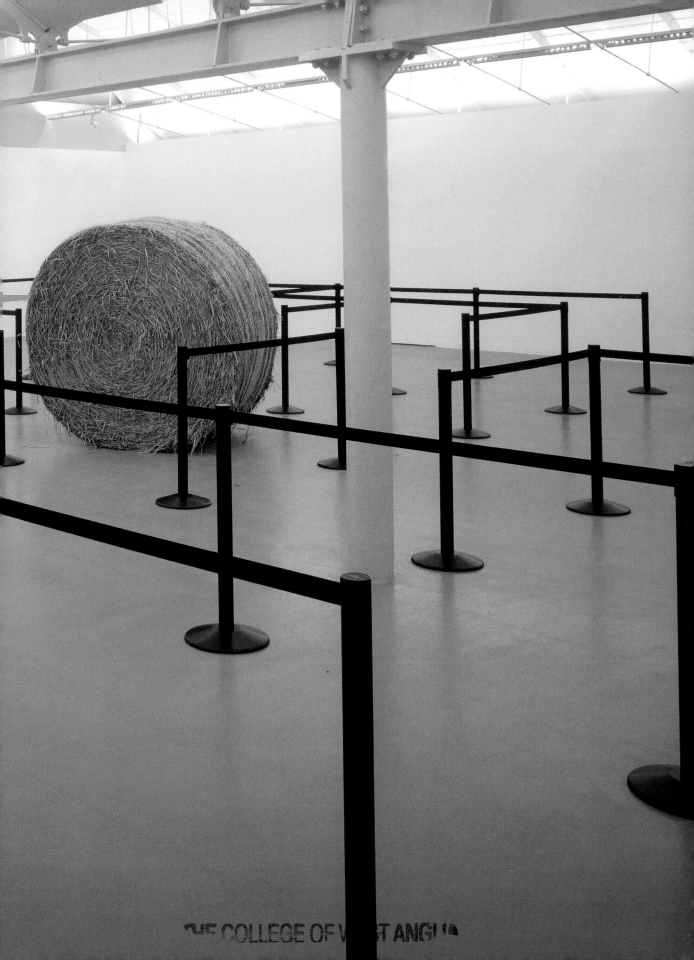

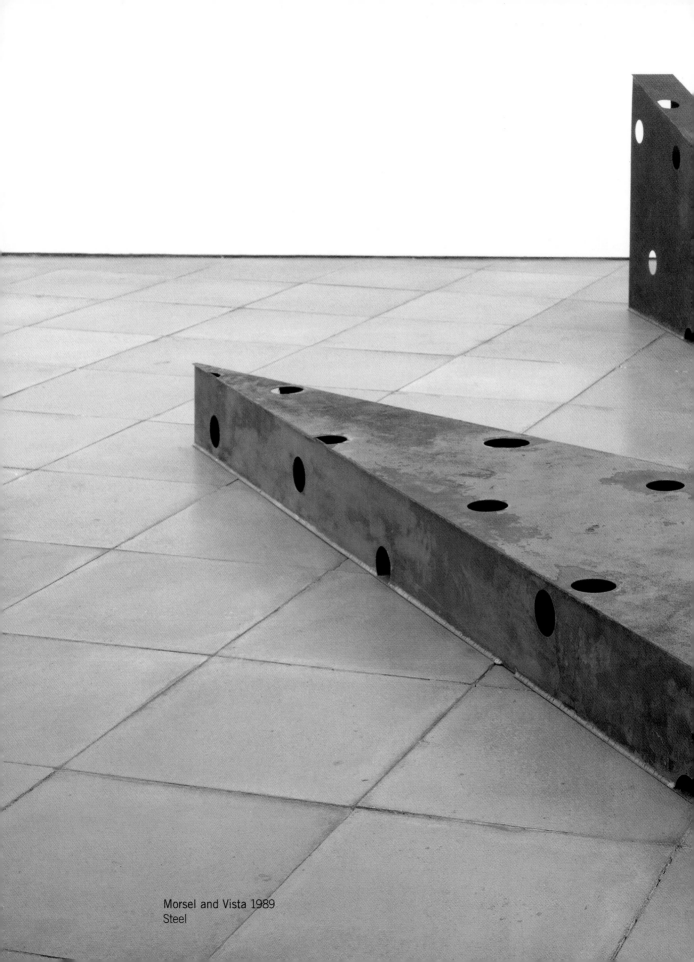

Morsel and Vista 1989
Steel

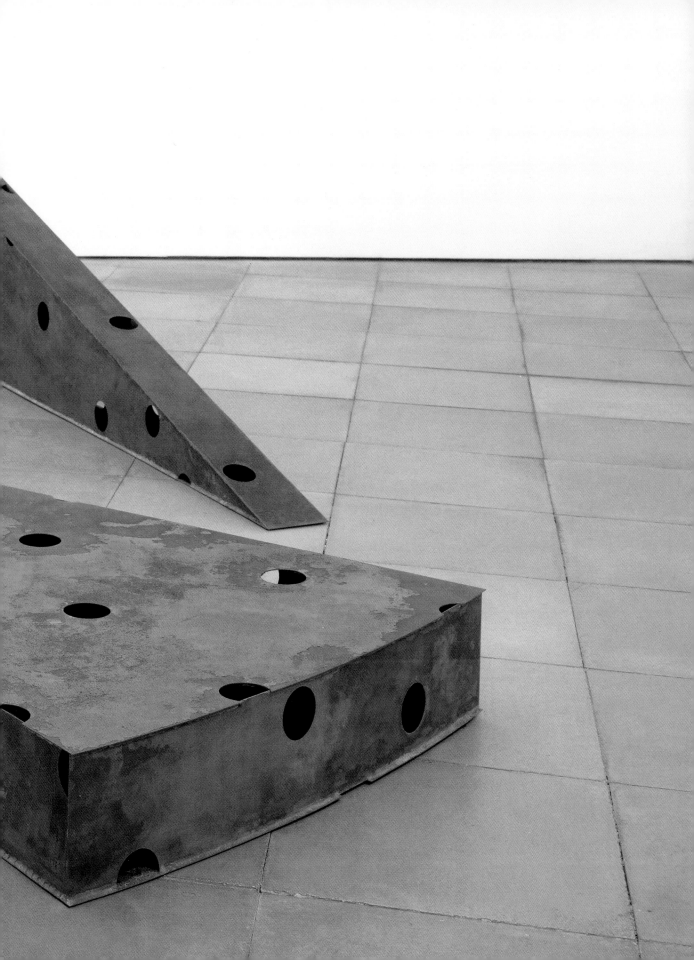

82

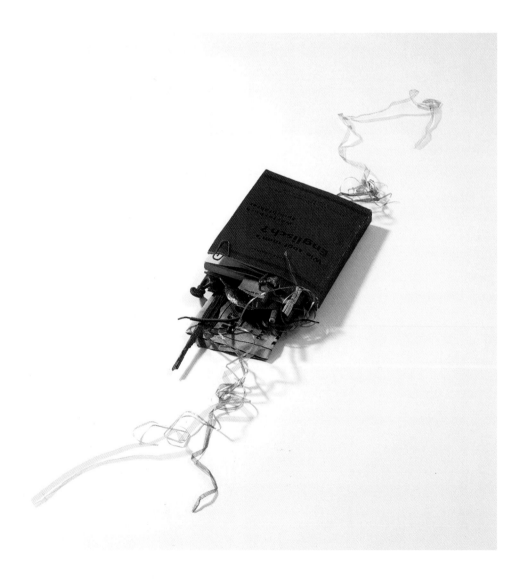

The Red Words (Die roten Worte) 1997
Aluminum foil, copper, wood and plastics

Witness 2005
Oak, dud lightbulbs, cable and galvanised clouts

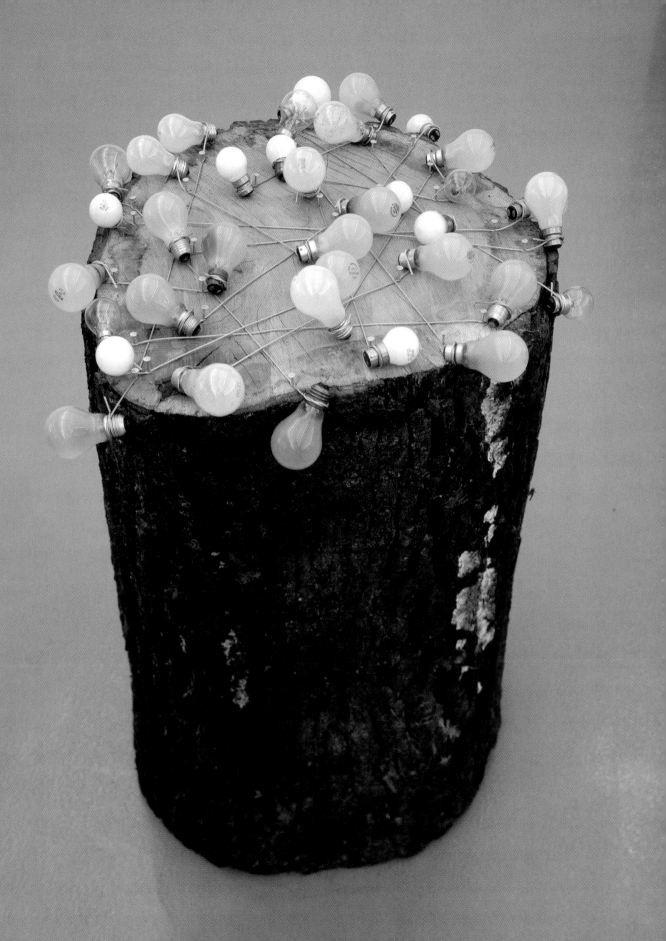

84

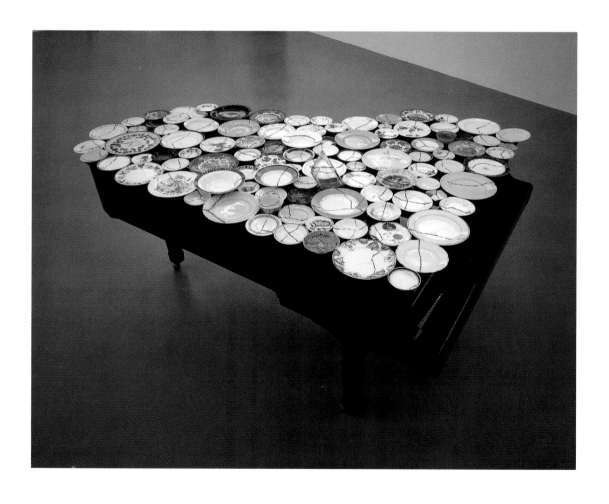

Brac 1996/2005
Grand piano with ceramic and epoxy resin

Pages 77–79 and 82–84
Photography by Roger Sinek/Tate Liverpool

Donors and Sponsors

The Trustees of Tate, The Director of Tate and The Director of Tate Liverpool are indebted to the following for their generous support:

For you three

Acknowledgements

Tate Liverpool would like to thank all those who have contributed to the realisation of this exhibition, and to the publication that accompanies it. In particular, we are grateful to Mark Lythgoe for his fascinating conversation with Richard Wentworth; to Michael Bracewell for his acute engagement with the artist's work; to Roger Malbert for his eloquent perspective on the 'stuff' and the man, and to all those who spoke on and off the record for giving us an insight into the artist as a person.

Sincere thanks go to Nicholas Logsdail and the staff at the Lisson Gallery, most especially Neil Wenman, whose enthusiasm has been invaluable. We appreciate the generosity of all the lenders who have supported the exhibition by allowing Tate Liverpool to borrow key works.

We are also grateful to Simon Groom and Laurence Sillars, Curators; Laura Britton, Education Curator; Helen Tookey for preparing the catalogue texts; to Herman Lelie and Stefania Bonelli for designing the catalogue, Linda Saunders for her editorial wisdom; and to Richard Wentworth himself, who has given so unflaggingly of his time, energy and vision in the conception, realisation and organisation of the exhibition.

The exhibition 'Richard Wentworth' is supported by Tate Liverpool Members. The Gallery gratefully acknowledges their support.

Richard Wentworth would like to thank warmly all those contributors and provocateurs who helped to generate both the exhibition and this publication.

First published 2005 by order of the Tate Trustees
by Tate Liverpool, Albert Dock, Liverpool L3 4BB

in association with
Tate Publishing, Millbank, London SW1P 4RG
www.tate.org.uk/publishing
on the occasion of the exhibition

Richard Wentworth
Tate Liverpool, 21 January – 24 April 2005

British Library Cataloguing in Publication Data
A catalogue record for this book is available from the British Library

ISBN 1 85437 574 1

Distributed in the United States and Canada by Harry N. Abrams, Inc., New York

Library of Congress Cataloging in Publication Data
Library of Congress Control Number: 2004116282

Designed by Herman Lelie and Stefania Bonelli
Editor: Linda Saunders
Printed by Lecturis, The Netherlands

Photographs by:
Ant Crichfield: 80–81; Jens Honig: 67; Dave Morgan: 2, 9, 11, 12, 13, 30–31,
44, 55, 58–59, 72; Marcus Müllenberg: inside front cover, 35, 66; Georgio
Mussa: 69; Sue Ormerod: 48; Mike Parsons: 23, 60, 71, 76; Andrew Putler: 38;
John Riddy: 17, 34, 40–41, 42–43, 70; David Tolley (www.davidtolley.com) 15,
32–33, 51, 63, 64, inside back cover; Michael Tropea: 37; Stephen White: 16,
18–19; 57; Gareth Winters: 28, 29, 61.

Cover: Fragment of decking from Tangier–Algeciras ferry 2004
Inside front cover: Spaziergang 1997
Inside back cover: Idiot Circle 1981

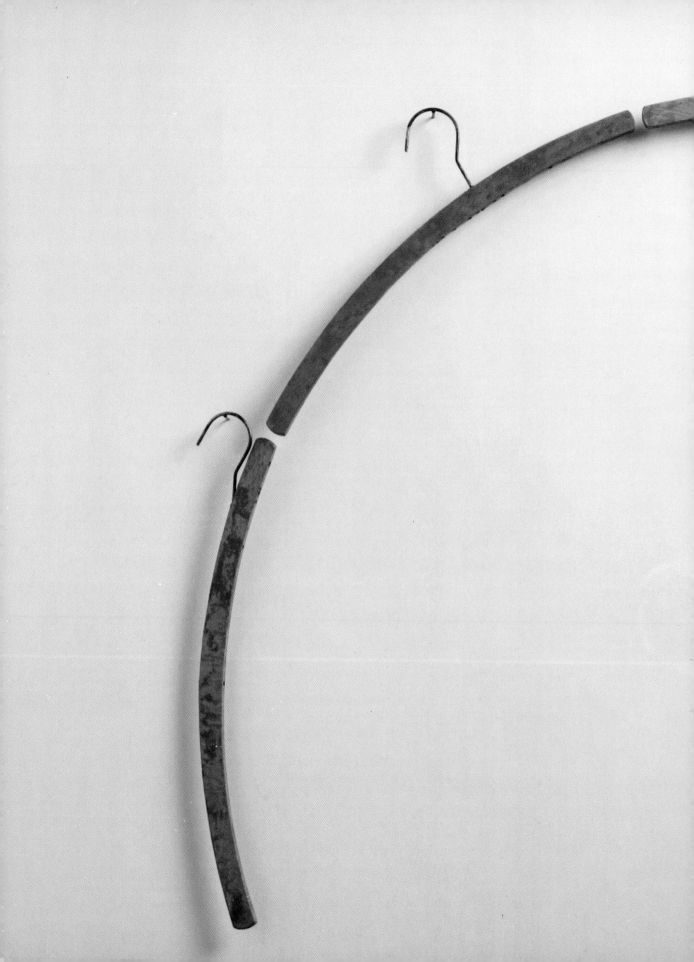